A BROOKLINE BOYHOOD
in the
1930S AND 40S

JIM HARNEDY

AMERICA
THROUGH TIME®
ADDING COLOR TO AMERICAN HISTORY

America Through Time is an imprint of Fonthill Media LLC
www.through-time.com
office@through-time.com

Published by Arcadia Publishing by arrangement with Fonthill Media LLC
For all general information, please contact Arcadia Publishing:
Telephone: 843-853-2070
Fax: 843-853-0044
E-mail: sales@arcadiapublishing.com
For customer service and orders:
Toll-Free 1-888-313-2665
Visit us on the internet at www.arcadiapublishing.com

First published 2017

Copyright © Jim Harnedy 2017

ISBN 978-1-63499-027-1

Typeset in 10.5pt on 13pt MinionPro
Printed and bound by CPI Group (UK) Ltd, Croydon, CR0 4YY

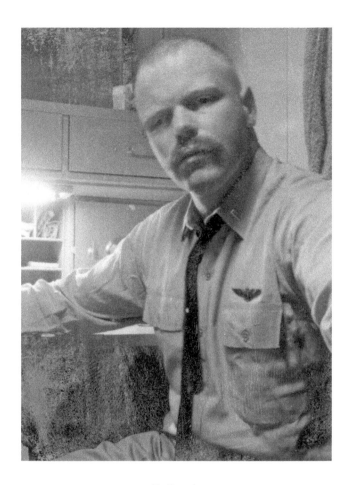

To Randy,
my best friend, who helped make
my growing up years a wonderful adventure.

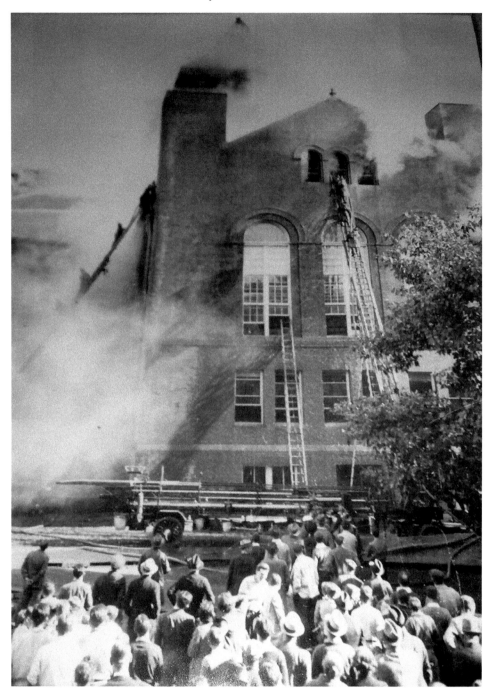

On the morning of September 25, 1936, my cousin, Mary Raulinaitis, took me in my stroller down to see our new Sumner Road home. When we reached the intersection of the Worcester Turnpike and Sumner Road, we saw smoke. When we reached my new house, we could hear fire engines at the bottom of the road. We went directly down to the bottom of the road and could see that Brookline High School was ablaze.

Contents

A Saturday Night Tradition

For as long as I can remember, Saturday night meant having dinner with the Harnedy clan at Grandma's house. The Harnedy clan were Brookline, Massachusetts, townies. Grandma Harnedy was born there in 1862 and her parents, James and Annie Donovan, had settled there in 1860 after emigrating from Maritime Canada (most probably, Cape Brenton, NS, based on data from the U.S. 1910 Census and Massachusetts State Archives).

Grandma met and married my grandpa, Timothy Harnedy, in 1888 at St. Mary's Church in Brookline. My grandfather came to America with his brothers, James and William, from their ancestral home in Bantry, County Cork, Ireland. Timothy and James both lived out their lives in Brookline, but William returned to Ireland.

My grandparents had seven children. James (Jim), my dad, was the eldest; next in line came Mary, who died as a result of the 1916 influenza epidemic; then William (Bill), Margaret, George, Helen and Julia Grace, who died at age three.

Uncle Bill was the bachelor of the siblings. After graduating from Northeastern University and taking a job with the post office, he saved enough money to purchase a large Victorian style home on Walnut Street that became headquarters for the Harnedy clan. Here Bill, Grandma, Aunt Margaret and her husband, Uncle Billy Raulinaitis, and my cousins, Mary, Junior and Peggy Ann, lived. Three houses down on Walnut Street was the home of Uncle George and Aunt Annie and my cousins, John and Mary, while three homes up in the opposite direction lived my Aunt Helen and her husband, Uncle Arthur Clasby, and my cousins, Joan and Ed (later to join us, Martha).

On Saturday between 5 and 5:30 p.m. everyone descended upon Grandma's kitchen for our Saturday night ritual. Grandma had been busy all day preparing for our arrival. The traditional meal's main course never varied: it was always New England home-baked beans, hot dogs and homemade brown bread. Dessert was usually home baked pie—the type could vary by season: apple, blueberry, squash or mince.

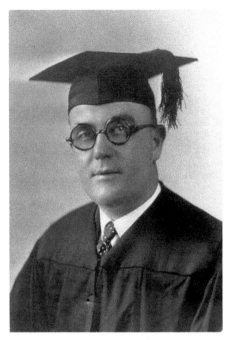

Left: Uncle Bill Harnedy's graduation photo from Northeastern University.

Below: Grandma Harnedy in her back yard.

The adults and older cousins all sat around a big oak table that was in the center of Grandma's large kitchen. We kids got to sit at a side table, which included Mary Harnedy, Peggy Ann, Ed and myself. Mary and Peggy Ann were a year older than me and Ed was several years younger. As I recall, our conversations were about what was going on at our schools and what mutual friends were doing. I suspect that my mother and aunts talked about family things and local gossip. Dad's brothers Bill and George, a firefighter along with brother-in-law Arthur Clasby, the town's civil engineer, were very tied in to the local town political scene. They and brother-in-law, Billy Raulinaitis, were all very active Brother Elks and this was always a subject of great interest to them on these Saturday nights.

The breaking of bread together was a form of family communion. The ritual ended when I was around 12, as grandma who, was then in her 80s, became very crippled by arthritis.

As my cousins and I became adults, we all left that safe enclave of Brookline that we had called home for lives in very different venues.

Five of us remain. We are now all elderly and have seen our children and grandchildren go off in search of their dreams across the U.S. and globe.

My hope is that these younger generations are able to find ways to develop new traditions to keep families close. One of my cousin's, Joan's daughter, is married to a Swedish national and now lives in Dubai, the capital of the United Arab Emirates, while Peggy Ann has a son, an engineer, permanently living in China with his Chinese wife and sons.

I realize we live in a much more mobile and complex society, but I'm concerned that while iPads and smart phones have a place, they cannot replace personal interactions between people.

The Fire at Brookline High School

I came into the world on Saturday, October 15, 1932, at the New England Baptist Hospital, in Boston, Massachusetts. My parents were James G. (Jim) Harnedy and Helen (Flanagan) Harnedy. Herbert Hoover was president and the nation was in the darkest days of the Great Depression with more than 20 percent unemployed. National elections were only several weeks away and Franklin D. Roosevelt, the Democratic candidate for president, was blaming Hoover for the economic mess. After a brief stay in the hospital, my parents took me to my new home in Brookline. I was to live on the third floor of a three-decker apartment building at 94 Dudley Street for next four years.

Election day, Tuesday, November 8, 1932, saw Franklin D. Roosevelt and his vice presidential running mate, John Nance Garner, elected in a landslide victory over Republican President Herbert Hoover. I later found out that my parents had both voted for Roosevelt. Like most Americans, they had felt the effects of the Great Depression. My father was a lawyer in the Claims Department of the Massachusetts Bonding and Insurance Company; when the stock market crashed, he was given a choice to leave or take a 50 percent cut in pay. In 1929 he was making $10,000, and he elected to take the cut to $5,000, but they allowed the lawyers who chose that option to have a small practice on their own time. My mother was a professional singer and after the crash there were very few engagements for singers. All in all they were quite lucky by comparison with the hard times of so many friends and relatives.

On Sunday, November 13, I was baptized at St. Lawrence Catholic Church. My godparents were my uncle, William F. Harnedy, and my aunt, May Craffey. This was probably the most exciting thing that I experienced for quite a while.

Most of my time as a baby was spent like most babies, eating, having my diapers changed and sleeping. Besides my parents, our home was shared with two wire fox terriers—"Wee" and "Peppy." I soon came to love my doggy friends. This love for dogs has remained a constant through my whole life.

Obviously, my folks introduced me to the holidays as they arrived and took me to visit my grandmother, aunts, uncles and cousins as well as close family

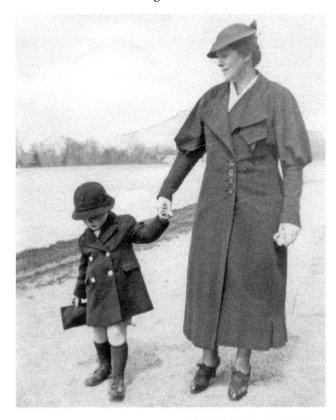

A stroll with mother at the Brookline Reservoir.

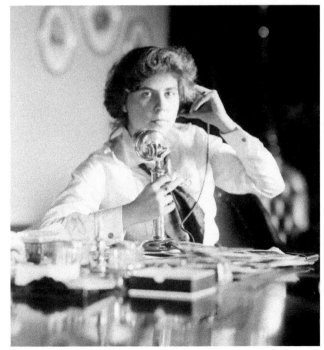

My earliest memory of a telephone was a tall standing device on a small table in the hallway of our Dudley Street, Brookline, apartment. I learned much later in life that these types of telephones were called candlestick phones, and were popular during the 1920s and early 30s.

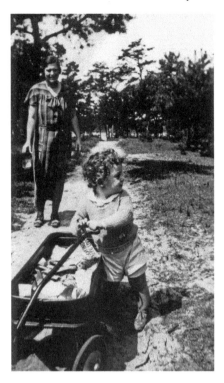

Fun with my little red wagon.

friends. My mother took me for walks in our neighborhood, especially across the street from our house on the walking path of the Brookline Reservoir.

In the summers that followed during these early years of my life, we spent our family vacation time on Cape Cod. I always enjoyed going into the ocean and playing in the sand with my toy pail and shovel. I can remember when I was around three, I enjoyed kite flying on the beach with two of my cousins. During the fall season, my parents would often take me to Beverly Farms to visit the kennel where my dad kept some of his Wire Hair Terrier show dogs. Mr. Bill Harvey, the kennel owner and professional handler, who handled dad's dogs in shows, was also a terrier breeder of Scotties and Welsh Terriers. On a visit to the kennel on a weekend just after Thanksgiving in 1935, Mr. Harvey told me to go in and check on a new litter of Welsh Terrier puppies. Naturally, I loved the little pups. He told me to pick out the one I wanted. My dad said we had lots of dogs, but Mr. Harvey said I needed to have one of my own. This is how Brownie became part of my life. That winter, my mother would read stories and poetry to me nearly every afternoon and dad would take me coasting on snowy weekends.

Starting when I was about three, I began to understand more about what was going on about me. I obviously was oblivious to what was happening in the wider world, which did not affect me. In mid-June of 1936, my mother took me out for a walk to hopefully point out a luxury airship—the German Zeppelin

Hindenburg, which was making one of its early transatlantic flights from Frankfurt to Lakehurst, New Jersey, and was supposed to fly over our area on its flight path south. It did pass over just where we were and my mother pointed it out to me. I must say it didn't make much of an impression. I never knew until years later that this huge airship crashed a year later at Lakehurst, New Jersey.

During the late summer of 1936, after we had returned from the Cape, my parents started in earnest looking to buy a house. They wanted to be in a new home when I started kindergarten the next year. My mother would arrange for someone to babysit me so that she could meet with a real estate agent to check out homes in various Brookline neighborhoods. In early September, they settled on a home on Sumner Road.

On September 25, 1936, my mother asked her niece and my first cousin, Mary Raulinaitis, to babysit me, so that she could do some shopping. Mary was about eighteen years old, having graduated from Brookline High that past June. That morning, she arrived around 10 a.m. and decided to take me in a stroller down to see my new house. As we reached the intersection of Sumner Road and the Worcester Turnpike (Route 9), smoke filled the early fall air. The smoke became even thicker as we proceeded down towards our new home. When we reached our house, fire trucks could be heard at the bottom of the road, so we went

Above left: Dad and I at a beach on the Cape.

Above right: Uncle Bill Harnedy and I.

directly to where all the noise was coming from. The blaze was coming from Mary's high school, and she was worried her sister, Peggy Ann, could be inside. There were police all over the place, so Mary, pushing me, went to talk to the first officer she saw and found that all the students had been safely evacuated from the school. At that time, the high school also housed one kindergarten class, which Peggy Ann had just started in several weeks earlier.

After Mary heard that her sister was safely out of the building, she pushed me over to the Cypress Street playground to watch the fire. We stayed and watched the fire for some time. Engine companies from all over the area came to help put out the fire. Unfortunately, the school was totally destroyed.

Years later I learned that my Uncle George Harnedy, a firefighter, was hurt battling the blaze. My cousin, Peggy Ann Raulinaitis, told me that her teacher got all the kids out as soon as smoke had been detected in the building. She also told me that she continued her kindergarten year at the Pierce School.

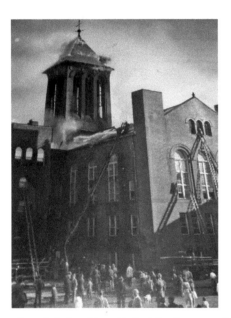 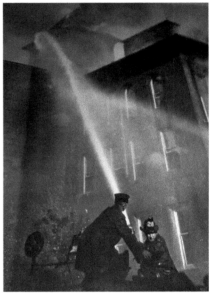

Above left: Brookline High School in 1936 had a kindergarten class housed within the facility. My cousin, Peggy Ann Raulinaitis, Mary's young sister, was a member of that class. Fortunately, all students, faculty and other school staff members were evacuated from the building, and there were no injuries. *Photo courtesy of Harvard University Athletics*

Above right: Firefighters from around the greater Boston area came to provide help for this huge fire. I found out years later that my Uncle George Harnedy, a Brookline firefighter, was injured in the fire.

My Neighborhood

In the fall of 1936, my parents purchased our new home on Sumner Road in Brookline. It was approximately one-and-a-half miles from the apartment house at 94 Dudley Street that I had lived in all of my young life. We physically moved into our new home in late October, about a month after the fire that destroyed Brookline High School, just down from our new house.

Sumner Road, although not a long road, has two branches. The top section intersects with Boylston Street (Route 9, the Worcester Turnpike) and runs down across Clark Road and then into Blake Road for a very short distance before turning back into the second leg of Sumner Road.

It was on this second section that our house, at 122 Sumner Road, was located. It was the third house up from where Tappan Street and Greenough Street intersected, and where Brookline High School was located.

The neighborhood was made up of a combination of single and two-family dwellings that were built during a housing boom in the early 1920s, after World War I. Our home had been built around 1924 for a cost of $24,000 and my parents bought it during the Great Depression for $5000 from a Ms. Kimball, an attorney who lived there with her mother, but had decided to move to their summer property in Dublin, New Hampshire.

The residents on our section of Sumner Road were middle class townies who all had known each other a good portion of their lives. My mother was one of the exceptions, as she was from Boston and not a local.

The first home on our side of the road as it turned in from Blake Road was a large single home owned by Mrs. Morrison, an elderly widow. Her husband had been a doctor and had died several years before we moved to Sumner Road. The next home, also a single home, was owned by Mr. and Mrs. Poole. Mr. Poole was an engineer with Stone and Webster. The next home, which was next to our house, was a large Victorian home that was owned by the Brecks. This family included a mother and two sons who were in college. When the sons graduated from college, the mother sold the home to the Meehan family, another Sumner

Road neighbor. We lived in the next house, a large nine-room stucco home with two baths. Our next-door neighbor on the other side lived in a two-family home. The owners, Mr. and Mrs. Charles Clapp, lived on the first floor. Mr. Clapp was a plumber and Mrs. Clapp worked at Paine's store in Brookline Village. They had an adult son, daughter-in-law and a grandson, Warren Clapp, who was my age. He would come over to play with me when he visited his grandparents. The Gormley sisters were the tenants in the second-floor apartment. One sister was a social worker and the other a secretary at First National Stores main office. The last home on our side of the road, where it intersected with Tappan Street, was owned by Mr. Conner. He was a chauffeur for a wealthy family and when at home, spent a lot of time polishing the big black Packard car that he drove.

Directly opposite Mr. Conner's was a two-family home owned by the Carriero family. Mr. Carriero and his wife owned and operated the Village Flower Shop with Mr. Carriero's brother and sister-in-law. The Carrieros occupied the second floor apartment with their three sons, Fred, Buddy and Dick. In the fall of 1936, Fred was twelve, Buddy nine and Dick five. Mr. & Mrs. Delrimple lived in the first floor apartment. The Delrimples did not have any children and Mr. Delrimple was a jeweler. The property abutting the Carrieros on the Tappan Street side was the Brookline Gymnasium and Gym Yard, which became my favorite place to play with my friends. Going up Sumner Road from Carriero's house was another two-family home owned by Mrs. Allison. She lived there with her twelve-year-old son, Jacky, in the second-floor apartment. Mr. and Mrs. Reynolds lived on the first floor. Mr. Reynolds was an engineer and like Mr. Poole worked for Stone & Webster. The next home was owned by Mr. and Mrs. Jack Kearnan. Mr. Kearnan was self-employed as a carpenter. The two-family home abutting the Kearnan's was owned by the Ryans. They occupied the second-floor apartment. Mr. & Mrs. Ryan had two sons and a daughter. When we moved in, Ed was thirteen, Helen eleven and Donald seven. Mr. Ryan owned a garage across the street from Fenway Park that specialized in selling batteries and tires. Downstairs, Mr. Moynihan, Mrs. Ryan's father, and sister, Ms. Moynihan, lived. Mr. Moynihan was an elderly man and retired, and Ms. Moynihan was a secretary at Boston's Children's Hospital. Next to the Ryan's was a two-family home owned by Mrs. Straine. In late August of 1937, Mr. and Mrs. Filmore, with their daughter, Shirley, and son, Randy, moved in with Mrs. Straine, who was Mrs. Filmore's mother. Randy was to become my best friend. Occupying the second floor apartment was the Lee family, which consisted of Mr. and Mrs. Oscar Lee, their daughters Carol, thirteen, and Virginia, three, and son, Dick, eleven. A few years later, the Lee's purchased the two-family home at the top of our road from the Meehans, who had purchased the Breck's home next to us. When that move occurred, Mrs. Mackenzie (another daughter of Mrs. Straine), with her seven-year-old son, Winsor, moved into the second-floor apartment. Abutting the Straine house was a two-family home owned by Mr. Laddie MacKenzie (no relation to Mrs.

Marjorie Mackenzie next door). Mr. Laddie MacKenzie had an adult daughter and son, Laddie Jr. They lived in the upstairs apartment. On the first floor were the Robinsons. Mr. and Mrs. Robinson had two daughters, Gerry, eleven, and Ruth, three, and a son, Bill, ten. The next house going up the Sumner Road was owned by the Quinn family which consisted of Mr. and Mrs. Quinn and her elderly mother. Mr. Quinn worked as a gardener on a large estate in Brookline. The Camerons owned the two-family home next door. Mr. and Mrs. Cameron occupied the first-floor apartment. They did not have any children. Mr. Cameron was Director of Athletics for the town of Brookline. Upstairs lived the Donovan family. Mr. and Mrs. Donovan had a daughter who was eleven and a son, Jimmy, who was about two. A two-family home at that section of Sumner Road that turned into Blake Road was owned by Mr. and Mrs. Meehan. The Meehan family occupied the second floor. In addition to Mr. and Mrs. Meehan, there was Mrs. Cunniff, Mrs. Meehan's mother, as well as the four Meehan children. There were three daughters: Ann, twelve, Betty, eleven, Katherine and a son, Hubert (Herby) who was a few months older than me. A few years later, the Meehans bought the Breck's home and became our next-door neighbors, while the Lees purchased the Meehan's home. Directly across on Blake Road stood an elegant, white, two-family home that was jointly owned by Mr. and Mrs. John Sullivan, who lived in the second-floor apartment; on the first floor was the other co-owner, Happy Hicks, Mrs. Sullivan's brother. He owned the gas lights that he lit each night to illuminate the town's streets.

Moving slightly beyond the immediate neighborhood boundaries to where Sumner Road intersects with Tappan and Greenough Streets, Brookline High School stands. Directly across Greenough Street from the High School is the Cypress Playground. It covers a large area and has two distinct baseball fields plus a smaller area for kids to swing. In the winter, a wooden outdoor running track was assembled on the baseball diamond directly across from the high school to allow for winter track practice. During the winter, when the weather cooperated, the other baseball diamond area was flooded for skating. On the Tappan Street side of the playground was the Brookline Gymnasium, Brookline Swimming Pool (known as the tank) Mechanical Training Building, and next to it, the Brookline Hills Railroad Station which offered thirteen-minute train service to Boston's South Station on what was called the Highland Branch.

If you came to the intersection of Tappan Street and Cypress Street and took a right turn onto Cypress and walked approximately one-fourth mile to where Cypress intersected with Boylston Street, you would find what was our local shopping area. Located here were two drug stores, a fish market, Dorothy Muriel's Bakery and A&P Market.

The Hurricane of 1938

In late August 1938, my mother received a phone call from her cousin, May Morton, who lived in San Francisco. My mother had never met her cousin but they had kept in touch through letters and by phone, as May was a senior-level telephone operator in San Francisco and could make many long distance calls. On this occasion, she said she would like to come east and meet our family. She planned to fly to Boston in mid-September if that was a convenient time for a visit. Mother assured her that mid-September was perfect and that she was excited about her planned visit.

Needless to say my mother wanted to make this visit very special, and provide an opportunity for her to meet as many members of the family as possible, as well as see a good section of New England.

I had just started first grade in September of 1938 and was excited that Randy Filmore, who was my age and would become my best friend, had just moved into his grandmother's house across the street from our house. His mother was a Brookline native and wanted Randy to start school here. The fact that a relative who lived way out West was coming to visit by plane made that September super special.

I don't recall the specific date in mid-September that May Morton's plane flew into Logan Airport, but we were certainly there to meet her. It was the first time that I had ever been to an airport and I loved seeing all the planes. We watched all the folks disembark the plane and my mother recognized May from photos that they had exchanged.

On the ride home from the airport I sat up front next to my dad as my mother sat in back in order to more easily talk with May. After arriving home, my dad helped May bring her bags in and up to our guest room. I remember that shortly before dinner, May called to me and said that she had something for me. I went to her room and laid out on the guest room bed was a cowboy suit, including a cowboy hat and pistol with a holster. I was thrilled with my gift and couldn't wait to show it to my new friend Randy.

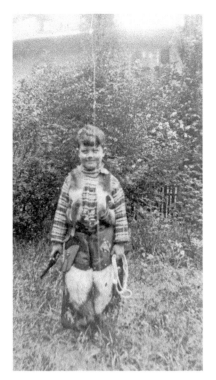

A cowboy outfit gift from May Morton.

Before dinner my mother called my aunt, May Craffey, and my uncle, John Flanagan, to let them know that our cousin, May Morton, had arrived safely from California. We had dinner and then I went to bed.

The next morning after breakfast, I met up with Randy and we walked to school. Naturally, I told him all about my gift of the cowboy suit and promised to show it to him after school.

The next few evenings, my mother had scheduled dinner parties. The first one was for her sister May and her husband, P. J. Craffey, and brother, John Flanagan, and wife, Mary, to have an opportunity to meet their Californian cousin. The second party was a few evenings later and it was a larger group of mother's relatives from her mother's side of the family.

Days were spent on local trips around greater Boston. My dad said New England falls are special and thought a trip to southern New Hampshire might let her see some early fall foliage and some historical locations in Concord and Lexington. September 21 was chosen for our day trip. I was excited, as I was getting a day off from school to go on the trip. I'm sure that morning my dad turned on WEEI to catch the news and local weather from E. B. Rideout. To my knowledge no alarm was given about a potential storm to hit New England. So we all piled into our 1935 Dodge and set off on our excursion.

As I recall, it was a warm, muggy, grey day. We headed north on back roads so that May could get a feel for the area. In late morning, we were in north central Massachusetts close to the New Hampshire border. Once into New Hampshire we saw that the local brooks and rivers were super high, and in some cases spilling over their banks. We crossed one small bridge and it didn't feel very safe. Our second experience a short time later really scared us, especially my mother and May, as just after we and another car crossed this little temporary wooden bridge, it collapsed into the river. The day went downhill from there.

We had planned to have lunch in a restaurant in Keane, New Hampshire, but that turned out to be impossible as the downtown area was completely under water. My dad put me up on his shoulders so that I could see how high the floodwater was on the Main Street of Keene. I can remember that only the very top of the street cars were visible. Our visit to the city of Keene, New Hampshire, was thus cut short, and we decided to head for home. I don't believe we had any lunch, as every place was closed.

The next event of the day that stands out occurred on a backcountry road in the Lexington, Massachusetts, area. Driving along, my dad thought that we had gotten a flat tire. He stopped the car and got out and checked the tires—there was no flat tire. The force of a strong wind was simulating a tire problem. The intensity of the wind continued to pick up and soon a small tree fell a car length ahead of us and a minute or so later another tree fell behind us. My mother told me to get down on the floor of car and to be careful of the eggs we had bought in the morning. My dad yelled back, "The hell with the damn eggs, I'm just not sure if any more trees are going to come down." By this time, mother and May Morton were scared to death. May said that she had lived through the San Francisco earthquake of 1906 and that it was not as frightening as what she was then experiencing. Little did we know at the time, we were out in the middle of the Great Hurricane of 1938. We were to learn later that the only previous hurricane to hit the area was on September 23, 1815, and obviously no one was alive from that era to communicate to the public about that storm. As we sat in the car blocked by fallen trees, a pick-up truck came to the tree blocking us in front, two men jumped out of their truck and pulled the tree to the side of the road, allowing us to continue on our trek home.

We were all thankful to get home to Brookline safely. Along the way we saw lots of trees and electric wires down. Our home came through the storm without any damages. My dad had the several poplar trees in our yard topped during the summer, which probably saved us from having problems.

Due to the hurricane damage, all schools were closed the next day. That morning, Mr. Driscoll called and asked my mother if I could go with him and his daughter, Mary, a first grade classmate, on a ride down to Cape Cod to assess the hurricane damage to several properties on the Cape. Mr. Driscoll was the owner of a Brookline-based contracting firm that was well known throughout Eastern

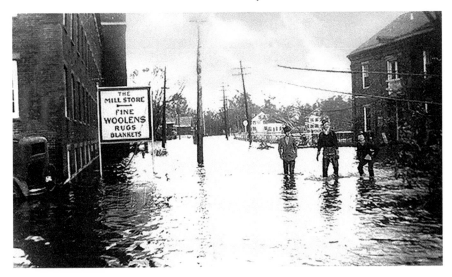

Our family trip to show my mother's cousin, May Morton, some early fall foliage in parts of New England not only put us in danger, but made us witness to the devastating flood in Keene, New Hampshire.

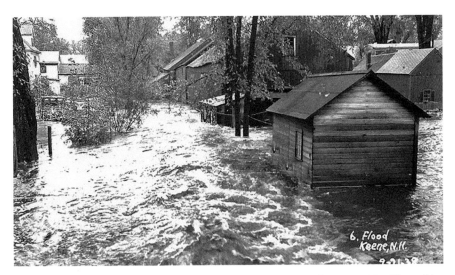

The 1938 flood and hurricane provided catastrophic damaging to the Keene, New Hampshire region.

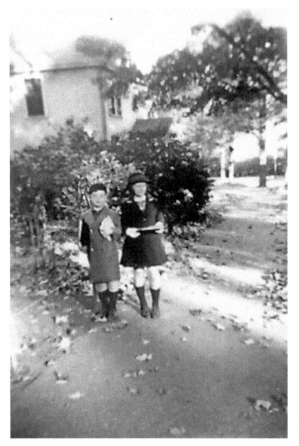

Mary Driscoll and I getting
ready to head off to school.

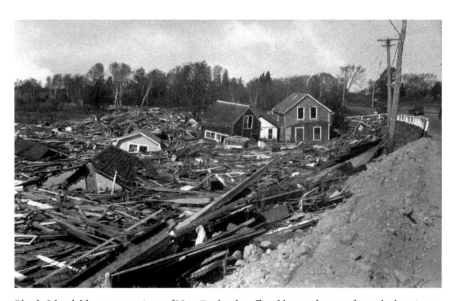

Rhode Island, like most sections of New England, suffered heavy damage from the hurricane.

Massachusetts. The Driscoll's lived up the street from us at 50 Sumner Road. The Driscolls were also an old Brookline family and he had been a star football player at both Brookline High and Harvard. He knew my friend, Randy Filmore, was a classmate of mine and Mary's, so he called Mrs. Filmore and also invited Randy on the trip. He and Randy's mother had known each other most of their lives as they had been high school classmates. Our mothers agreed to our going on the trip to the Cape. Mr. Driscoll picked us up around 9:30 a.m. and off we went to the Cape.

All along the way we saw uprooted trees and men from Boston Edison and other contracting firms busy cleaning up the mess the storm had made. Our first stop on the Cape was at a small hotel that had suffered damage to its structure when a large oak landed on its roof. We kids got out of the car and looked around at all the damage, while Mr. Driscoll talked and walked the property with the hotel owner. We next went to a town office building. This time we stayed in the car while Mr. Driscoll went inside to talk to town officials.

Next we went to lunch at a small restaurant that was open. I don't remember what he had to eat except we finished the lunch with ice cream cones. We then started home and each of us knew how awful the Hurricane of 1938 had been.

Broken Serenity

Thursday afternoon, August 10, 1939, was a cloudy and humid day in Brookline, Massachusetts.

I waited anxiously on the porch for Dad to arrive. He was coming home early. Finally, I heard the train whistle of the Highland Branch train pulling into the Brookline Hills station. I knew he'd be coming up the street in a few minutes. After what seemed like an eternity for an almost seven year old, I spotted Dad walking up Sumner Road, laden with packages bearing the Iver Johnson label.

Dad yelled, "Son, wait 'till you see what I've got. You can be sure that we'll be set for the biggest ones that Moosehead has to offer."

After a quick kiss for Mom and me, we went inside to the living room to exam the loot Dad had brought home. First, Dad opened the large metal tube and pulled out a large bamboo fly rod. Next, he opened a shorter tube and pulled from it a beautiful casting rod. "Here Jimmy, this is for you," he said.

He then took out several boxes; one contained a grand assortment of trout and salmon flies, archer spinners, hooks and leaders. It was a kind of advanced Christmas. This, however, was to be very special vacation—it was to be my initiation to Maine—a kind of rite of passage.

The rest of that afternoon Mom and Dad spent packing our 1936 Dodge Sedan, while I daydreamed of what Maine and Moosehead Lake would be like.

We were to be gone for a little better than three weeks. We would not return until the day after Labor Day. Thus, we needed sufficient clothes and provisions for our stay, as there were no stores on Deer Island.

We went to bed early that night so we would all be well rested for our long pilgrimage. This was to be no short jaunt, but a two-day safari into Maine's north woods.

We had breakfast early that morning and were on the road by eight o'clock. Our car looked like a covered wagon that was used to cross frontier country in

a western movie that I had seen. My Welsh Terrier Brownie and I sat in the back seat crunched between suitcases, knapsacks and other vacation paraphernalia. Our first day destination was the Senator Hotel in Augusta.

In August of 1939, there was no Maine Turnpike or Interstate, only Route 1 and secondary roads. The trip from Brookline to Augusta took between six and seven hours. We arrived mid-afternoon at the state capitol. After checking in to the hotel, we walked around a bit to loosen up our stiff muscles and let Brownie have some exercise after a long cramped ride. We had an early supper in the hotel dining room, and afterwards, while Dad chatted with some of the folks in the lobby, Mom and I took Brownie for another walk. Again, we made sure we went to bed early, so that we'd be ready to set out by 7:30 a.m., as we still had a long ride ahead of us. I can remember asking "how long 'till we get there?" and my dad answering, "We will get to Deer Island late this afternoon if all goes well." Shortly after noon we reached Greenville. In that era, that was the end of the road. Now we had to catch a boat ride down the lake to the Capen's family farm and sporting camps on Deer Island.

My eyes couldn't believe the vastness of the region. After boarding the boat that would take us to our destination, Dad told me that it wasn't a short boat trip. As we traveled over the water, Dad pointed out various landmarks but my level of concentration was looking to see signs of wildlife. I thought that the boat trip was quite uneventful as I had not seen any black bears, deer or moose. Members of the Capen family were on the dock to greet us and help with our gear. By late afternoon we were well settled in our camp.

Ray Capen, who met us on the dock, suggested that after supper we go up to the pasture behind the barn and hide behind the stone wall, as deer generally came out into the pasture at that time.

Naturally, I was eager to see my first deer. Right after finishing supper we walked up the trail to the pasture and hid behind the stone wall. Within a few minutes, though it felt like forever to me then, several does arrived. I was thrilled.

The warm days and crisp evenings of late summer seemed to blend easily into each other. Each day we were either out on the lake trolling or fishing off of the island's rocky shoreline. For late summer we were very lucky—perhaps for me it was beginners' luck. The fact is, we caught lots of very good-sized trout and salmon.

Between fishing, hiking the island's trails, deer watching, hanging around the barn and just adjusting to the serenity of the Moosehead wilderness, I was quickly hooked on Maine.

The food at Capen's farm/lodge was something special, especially their baked blueberry pies. To this day, I have not found their equal.

Since there was no electricity on the island, everyone turned in early and got up at the crack of dawn. This was quite a bit different from the way things were back in the flatlands of Brookline.

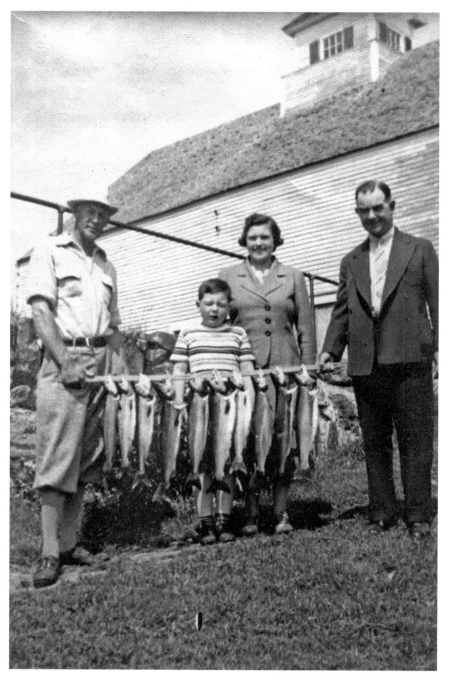

Going home with quite a catch from Deer Island, Moosehead Lake.
Left to right: Ray Capen, Jim Harnedy Jr., Helen Harnedy and Jim Harnedy Sr.

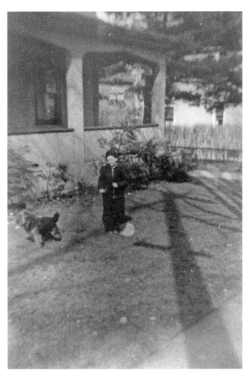

Brownie and I standing in front of our
Sumner Road house.

Dad did insist on keeping somewhat connected to the outside world, so he
brought along his battery powered radio. He kept telling both Mom and me
about his concern that the world might once again be thrown into a World War.
So, we listened to all the news that we could pull in.

Following lunch on Friday, September 1, 1939, Dad and I headed for the
southwest point of the island to fish off of the rocks in a deep hole, where the day
before Mom and Dad had caught a couple of nice brookies. When we reached
our destination, we put our lures on our lines and made our first casts.

Dad turned on his old Motorola and within a couple of minutes that old set
snatched from the ether waves the news that Hitler's Nazi forces had invaded
Poland.

Dad turned to me and said, "I want you to remember, son, that a nightmare
has just begun."

Unfortunately our vacation ended on Sunday, September 3, as it was time for us
to leave Deer Island and start on our long trek home. Yes—the serenity of Deer
Island had been broken, perhaps forever.

Emergency Surgery for a Maine Coon Kitten

I was excited! It was late June 1940 and I had just completed second grade at the John D. Runkle School in Brookline, Massachusetts, and my family was scheduled to leave for a two-week vacation in early July to Deer Island on Moosehead Lake in Maine.

The previous summer, I had been introduced to this wilderness region and to the fun of fishing for landlocked salmon, trout, and togue. My dad was an avid angler and had initiated me to his avocation.

In 1940, there was no Maine Turnpike or Interstate, only Route 1 and secondary roads. A trip to Maine's great north woods region was a two-day trek. The first leg of the trip was a 6 to 7 hour drive from Brookline to Augusta. We arrived at our first destination, Augusta's Senator Hotel, in the late afternoon. After checking into our room we went down to the dining room for an early dinner.

The next morning we were on the road again by 7:30 a.m. It was still a long drive of more than 150 miles from Augusta to Greenville, where the road ended. It was here that we would catch the mail boat to the Capen's family farm and sporting camps on Deer Island.

Ray Capen met us on the dock and helped bring our gear up to the lakeshore camp where we would be staying. After putting our luggage in the bedrooms, my dad was eager to set up our rods for our first venture onto the lake the next morning. Equipping the rods was a bit tedious and took some time. It required securing his reel to his fly rod and attaching to the line an appropriate leader and then an archer spinner as the lure he planned to use for catching salmon. Next, he outfitted both my mom's and my casting rods for a fishing adventure.

With the rods prepared for action, Dad hung them on the camp's porch as was the sporting camp's custom. We then walked up to the dining room for a farm fresh dinner.

Since there was no electricity on the island, everyone turned in early and got up at the crack of dawn, which was quite a bit different from life back in Brookline.

On our fourth morning, I got up and went out onto the porch to see if I could see the loons flying in. To my complete surprise, I found that one of the young Maine Coon kittens had wandered down onto the porch from the barn. He was attracted by the silver archer spinner lure on Dad's fly rod as it looked to him like a fun toy to play with. When he saw me, he grabbed the lure into his mouth and ran. Naturally, the more he ran the more he embedded the hook. I ran into the camp crying. After telling my dad what had happened, he told me to go and get the kitten and bring him into the camp. After catching the poor little guy, Dad cut off the line so that just a small piece of the leader connected to the lure remained in the kitten's mouth. We then took the kitten up to Capen's farmhouse. My dad asked Ray Capen if he had a small box with a cover that would secure the kitten and if he could get on the radio-telephone to the mail boat captain in Greenville and ask him if he could go to Harris Drug Store and pick up a can of ether and bring it over to the island on his late morning run.

Close to noon, the mail boat pulled into the dock and the Captain handed the can of ether to Ray. This set the stage for the emergency surgical procedure to commence.

My dad, Ray Capen and I were the surgical team. We all had a vital role to play for this medical event. The farmhouse dining room table was selected as the surgical center. Dad, using a sterilized razor blade, was to perform the surgery. Ray was the anesthetist responsible for administrating the ether using a dining room napkin as a cone to hold the ether. My job was to hold the kitten until he fell asleep. The whole procedure took only a few minutes. Upon its completion, the kitty was put safely into the security box. Several hours later he awoke and was ready to run and play. Thankfully, his gums heal quickly.

When we packed to return home we had a nice kettle of fish as well as a wonderful, loveable coon kitten that became a great member of our family.

I have lived in my adopted state of Maine for over 35 years and have returned to Moosehead Lake on many occasions. The Capen's Farm and sporting camps are no longer in business but Harris Drug Store has now served the area for over a hundred years. Michael Harris, the present owner pharmacist, told me it was his grandfather who saved the day.

My 8th Birthday

In the fall of 1940, my life was quite compartmentalized between school and after school fun. I was in Miss Shirley's 3rd grade class at the John D. Runkle School and after class I was totally hooked on playing football in the gym yard. The previous autumn, I had been initiated into football by the older kids in our neighborhood. I was big for my age, so they encouraged me to play on their "buck-up" teams which consisted of three or four kids per team, depending on the day. Goals (posts were imagined) and rules were subject to daily negotiations by the players. Naturally, we didn't wear any helmets, pads or uniforms. The only official football thing we had was a ball, which one of the older kid's brought each afternoon. No one had a set position to play and each of us was given a chance to run with the ball. Sports were perceived quite differently during my growing years. There was no Pop Warner football or Little League baseball. Soccer was not a sport that anyone I knew ever talked about. Girls were not involved in sports programs like today and parents were not involved with pre-high school sports, as there was nothing organized until that level. As a result, kids learned a lot of valuable lessons on the field involving negotiating skills and how to compromise. When kids' sports became organized, the skills once learned gave way to formal rules spelled out by adult coaches and a process that essentially turns today's kids' teams into farm clubs for high school programs. I personally don't believe that uniforms, equipment and coaching replace the skills that the kids learned in my era. Another benefit which I now see is that parents were not put under any heavy expense to purchase top-flight sporting equipment or the task of taking the kids to practice sessions and games afternoons and on weekends.

Back in the third grade, Miss Shirley introduced us to geography. As part of her introduction to this new subject, she brought into our class a book entitled *Richard Halliburton's Complete Book of Marvels* and invited us all to come up and look through it when we had a chance during recess.

A few days after the book's arrival, I decided to take a look at it. When I opened up this large book, I leafed through the pages, checking out the great photos of

both American and far away marvels. Of course all of these photos were black and white but that didn't distract from them, as I wasn't used to seeing photos in color. After this first scan of the book, I returned the next several days at recess to actually read about some of the book's marvels, including the Golden Gate Bridge, Panama Cannel and the Parthenon. I also enjoyed reading the author's opening letter to readers as he told how he as young boy found geography to be his favorite subject, as it provided him with an opportunity to daydream about exotic places and different kinds of people and actually planted the seed for him to become, as an adult, a world adventurer and global travel writer. I knew that geography would also be one of my favorite school interests. One night over dinner, I told my parent's about the Richard Halliburton book that Miss Shirley had brought into our class and how I really enjoyed it.

Our first geographic adventure in class was a trip to Baffin Island. We discovered that it was a Canadian Island that was mostly above the Arctic Circle, and it was west of Greenland and had an extremely cold climate with lots of snow. The native people were Inuit and the island was graced with a number of various wildlife species.

My birthday arrived on the 15th of October. We always celebrated birthdays at dinnertime when we were all home. That evening my dad arrived from work with a large bag. I knew that he must be carrying a gift but I had no idea of what it might be. The store's name on the bag was W. H. Brine, which I had never heard of. My mother suggested that we all go into the living room before dinner. After we had gathered together, Dad said, "I have something that I hope you'll like.

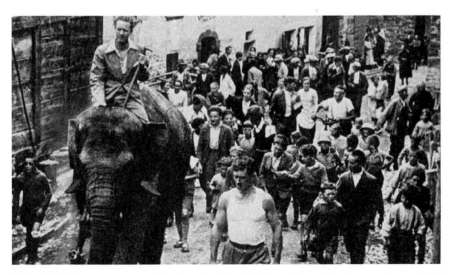

Richard Halliburton, author of the *Complete Book of Marvels,* introduced me to the world of adventure through geography. Here he is riding an elephant in the Alps, tracing the footsteps of Carthaginian general Hannibal.

Happy Birthday, Son." The bag from W. H. Brine's was quite heavy; I was excited, as I had no idea what could be hidden inside. When I open the bag, I couldn't believe the contents: a beautiful leather football helmet like the high school and college players wear. It was blue and white in color and naturally, I put it right on. In addition to this wonderful gift there was a regulation football jersey. You can be sure I was more than thrilled with my gifts. After I had calmed down a little, my mother provided me with another weighty present. I quickly unwrapped this gift and discovered it was a copy of Richard Halliburton's *Complete Book of Marvels*. I could not believe how lucky I had been to receive such perfect gifts. We next had a wonderful dinner followed by cake and ice cream.

Over my birthday dessert, Dad told me he had another surprise for me that we would share on Saturday. I had to wait for Saturday, as Dad had no intention of telling anymore about the surprise.

On the morning of October 16, I couldn't wait to tell Randy and my other friends about receiving an official high school team football helmet and jersey. Upon arrival in class, I told Miss Shirley that one of my birthday gifts was a copy of Richard Halliburton's book. She said that I was very fortunate and she hoped that I would enjoy the book for a long time.

When Saturday morning finally arrived, I could not wait to find out what Dad had in store for us. At breakfast, he broke his silence by saying, "Son, how would you like going to a college football game?"

In 1940, there was no professional football franchise in Boston. Football was strictly an amateur endeavor at the high school and college level. In Brookline, both Brookline High and St. Mary's had high school teams. At the college level, the two major local teams were the Harvard Crimson and Boston College Eagles. In that era, the Ivy League had some great teams and in 1940, Boston College under legendary coach, Frank Leahy, was enjoying a fantastic season. We usually listened on the radio to games each Saturday, but this Saturday we were going to see a game. Dad had gotten us ticket to the Harvard-Army game. I was very excited seeing the Harvard Crimson take on the West Point Cadets. It was a hard fought game and I believe it ended in a tie.

One night the following week, I told my dad how much I enjoyed Richard Halliburton's book and wondered if he would write any more books on interesting places in the world. Dad said unfortunately, he had died a year ago in March when a storm in the Pacific hit his ship, the *Sea Dragon*, a Chinese Junk that he had commissioned to sail to China in pursuit of another adventure and travel story.

The young men on that autumn Saturday of October 1940 would within several years be flying bombers over Europe, sailing on Naval ships, fighting battles in Africa and on Pacific Islands. One of the Harvard men shown in the photo is E. Peabody—Endicott "Chub" Peabody, he was soon named as an All American Lineman. He was to go on to serve with distinction as a Naval Officer

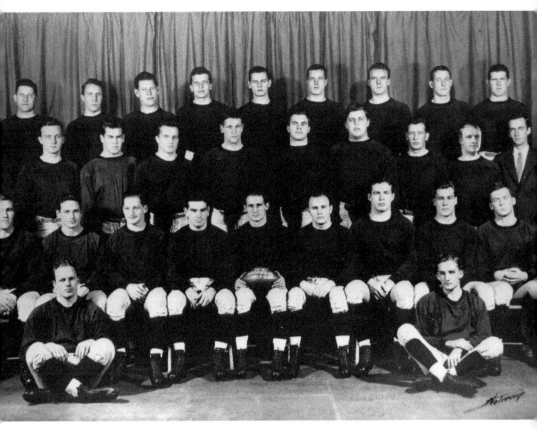

The Harvard Football Team
Back row: W. P. Brown Jr., R. G. Pfister, E. Peabody II, H. G. Vander Eb, F. C. Spreyer, L. G. MacKinney, G. W. Heiden
Middle row: Head Coach R. C. Harlow, B. Kelly, E. T. Lovett, C. B. Ayres, V. K. Miller, D. J. Lowry, F. Curtis, Manager J. McD. Atherton II
Front row: G. A. Downing, W. C. Coleman Jr., J. W. Gardella, Captain T. H. MacDonald, T. V. Healey, M. D. Hallett, J. T. Devine
Seated: F. M. Lee, E. J. Sargent

in the Pacific Theater and to be the recipient of the Silver Star. On his return from World War II he entered law school, graduated and practiced law. In 1962 he was elected Governor of the Commonwealth of Massachusetts. We are all grateful for these members of the Greatest Generation who gave so much.

As I look back and recall the reason that my 8th birthday has remained so special, the answer is very simple: my parents took the time to listen and observe the things that I as a kid was interested in. I hope that as a parent, I also listened to what my daughters were interested in.

Pearl Harbor Remembered

Sunday, December 7, 1941, started out like any other Sunday of late fall. Mother, Dad and I got dressed and prepared for church. We then left for 9:00 a.m. Mass at the Franciscan Friary, which was about a half mile from our house. We often walked but in bad weather or on cold days we drove. I think we drove on the 7th.

After Mass we went home and had breakfast. As was our Sunday custom, breakfast was usually orange juice or grapefruit, toast, eggs and bacon and milk for me and coffee for my parents.

Normally my dad put on the radio to hear the news but on this morning it was left off as he had some legal preparation work to do. Dad was a lawyer and on Monday, December 8, he had an important case in court and he wanted to do his work without interruption. In fact, he suggested to my mother that she and I might consider going to a movie in the afternoon. My mother loved movies and thought that was a great idea. She picked up the Sunday paper and went to the movie section to see what was playing at our local theaters. She told me that we would be going to the movies after lunch. I asked her which theater and she said, "The Brookline Village Theater." I'm sure I was excited about going no matter what was playing, and I certainly don't remember.

After lunch, when we were getting started out to the movies, I asked my mother if we were going to take the bus—"no dear, we're taking the foot train," which in mother's parlance meant we were going to walk. The Brookline Village Theater was a little over a mile from our house. That Sunday afternoon, as I recall, had typical late fall weather that made for a nice walk. There were no crowds at the theater box office buying tickets; in fact, there were few patrons inside for the movie. We took our seats and watched the movie that was playing.

When the show was over around 5:00 p.m. we left the theater into a dusk December afternoon. On the sidewalk, directly in front of the box office, a young boy was hawking the *Boston Record American* and shouting, "Japs bomb Pearl Harbor!" My mother bought the paper and we then caught the Chestnut Hill bus for Cypress Street.

We talked on our short ride that America was now at war. We got off at Cypress Street and walked home. When we arrived, we found my dad had finished his work and had our large console radio in the living room providing detailed coverage about the devastation at Pearl Harbor from the Japanese attack. My dad was so engrossed in the news that his important case was never mentioned.

My mother prepared our dinner and we ate while glued to the radio broadcast. Eventually that evening we all turned in for the night.

Monday morning, December 8, I got dressed, had breakfast and then headed out to meet my best friend, Randy Filmore, and walk to school. When we arrived in our class, our teacher, Miss Cushing, told our class that Mr. Roman, the principal, had announced that all students and teachers would be going to the auditorium to hear President Roosevelt's speech to the nation and Congress. In the late morning we all gathered in the auditorium and heard the president's short but critical speech to America.

We then returned to our respective classroom, but I don't think much in the way of regular classwork was done that day.

On the Home Front

December 7 changed both our nation and our neighborhood. The threat of being bombed brought the reality of World War II directly to every home. We were all required to put either dark green or black shades in our windows so no light at night could be seen outside from our houses. Each neighborhood had an air raid warden. The father of my best friend, Randy, Mr. Filmore had the duty in our area. He would check to see if there were any lights showing and if so, tell us to fix the problem. He would also practice air raid alarms and be on duty if a real raid were to occur.

My school was equipped with a siren to warn us of an attack. Practice air raid warnings were conducted both at night and during the school day. Like school fire drills, we had specific plans to follow for air raids. Thankfully, we never were faced with an actual bombing during the war years.

Cars had to have the top section of their headlights painted black so that their light beam would not reflect upward. The top portion of the globes of the gas lights that lighted the streets of Brookline were also painted black to obscure the light from the sky.

The next symbol of war to make its announcement in neighborhood windows were small red, white and blue flags with a blue star to acknowledge that someone from that home was off serving our country in the service. The first two flags donning windows were for Laddie McKenzie Jr., who had joined up on December 8 and had gone into the Marines as a pilot, and Billy Robertson, who had also joined the Marines. During the next fourteen months the remaining eligible young men from Sumner Road went off to serve our country. Thankfully all these neighborhood boys who were members of the Greatest Generation returned home safely from the war.

Rationing became a way of life. Nearly all food products were rationed, as were gas and tires for cars. One could no longer buy a new car or appliances as factories were now engaged in producing only products for the war effort. Recycling went hand-in-hand with the rationing. All canned goods had to be

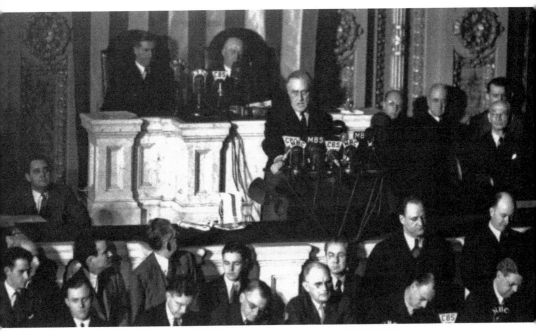

President Roosevelt, requesting Congress for a Declaration of War on December 8, 1941.

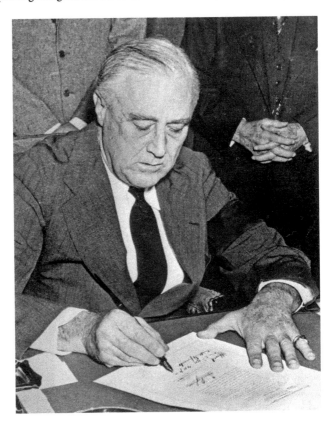

On December 8, 1941,
President Roosevelt
signed the Declaration
of War against Japan.

completely washed and have both their tops and bottoms removed. The paper packing also had to be removed. Finally, the can was crushed and made ready for its recycling. Papers were recycled as were the small aluminum wrappers on sticks of gum. Even fat was saved in containers, as it was recycled for ammunition. Hours were spent shopping with long lines waiting for meat, butter, cheese and sugar. My mother would have me stand in one line for a product while she stood in another. A new product called oleomargarine, a butter-like substance, came on the dairy shelves of stores during this period. In its initial offering, it looked like lard and had a red tablet that needed to be churned into this lard-like substance to give it a butter-like appearance. I can remember being given the job of mixing this product in a big bowl. We all thought that it was just okay as a substitute but that it would never replace butter. As I recall, beef, canned fruits and sugar were among the most difficult items to acquire. Each product took so many ration stamps, so you needed to watch the amount of stamps needed in the same manner that you watched prices.

Gas for cars was rationed on the basis of how much you needed to drive in performance of your job or profession. Traveling salesmen and doctors (they did daily house calls) and others involved in a lot of daily driving were given a C sticker to put on their car windshield with a corresponding ration stamp booklet for their monthly gas purchases. People whose work required less driving than those in the C category, but more driving than the average citizen, were given a B sticker and monthly gas stamps. My dad, a lawyer, fit into this category, as he often had to drive a great distance on a specific legal matter. Most folks were classified in the A sticker group and were given stamps appropriate for that category of driving. Since we lived in Brookline, a Boston suburb, we had good public transportation available.

Many other items that were not rationed were scarce. Many adults were smokers back then and cigarettes became hard to find on the home front, as priority for cigarettes was given to those in the military. I remember seeing two of my uncles who smoked, rolling their own cigarettes. Woolen blankets were another difficult to obtain commodity. Women like my mother had worn silk and nylon stockings before the war but once the war started, they were unavailable. I believe that these materials were used to make parachutes as well as for other war uses. A new fiber called rayon was used during this period for stockings.

As a student at the Runkle School, I was introduced to the role of banking and the merit of being thrifty. Each week, a person from a local Brookline bank would be on hand at an actual replica of a bank teller's station that was housed in a school corridor close to the cafeteria for the purpose of allowing us kids to open a savings account and deposit a portion of our allowance on a regular basis. After the start of the war the banking program ceased and switched to encouraging us to purchase War Savings Stamps. After we had saved a total of

My mother was a professional singer who helped the war effort by performing at a War Bond drive.

$18.75 the stamps would be converted to a War Bond, which would have a value of $25.00 at maturity in ten years.

Just after Pearl Harbor, posters and billboards sprang up everywhere urging Americans to help the war effort by purchasing War Bonds. In addition to these advertisements, a number of War Bond Campaign Drives were held. My parents were asked to host one of these drives at the newly opened Cleveland Circle Theater. My dad, was the MC for the event, and my mother, who was a professional singer, sang some patriotic songs. After that, the audience was asked to sign up for the bonds, and a movie was then shown to complete the drive.

Victory Gardens began to pop up in the Spring of 1942. By the Spring of 1943 these gardens had become a national sense of pride and demonstrated how citizens on the home front could actually participate in the war effort. A wealthy Brookline resident in the Chestnut Hill section of the town named Lyman offered to have his estate's land be used for Victory Gardens. The town of Brookline accepted this patriotic American's offer and agreed to manage the process. The town divided the land into 20 × 25 foot plots, rototilled the land and provided the gardens with access to water. For this service, the town charged a small fee. Plots were assigned on a first sign up basis. My dad signed up as soon as the town made the announcement, which guaranteed a good garden site.

Our home-based Victory Garden in the side yard.

That spring we had an 18 × 25 foot plot in our back yard rototilled for a garden. This gave us two good size plots to plant. My dad, who was quite knowledgeable about gardening, introduced me to gardening. We had an abundance of vegetables including beans, carrots, beets, tomatoes and squash. My mother canned a lot of the vegetables that provided us with vegetables over the winter, and certainly reduced the amount of food stamps we needed to use for canned goods. That same spring, we also planted several fruit trees in our yard but it took a couple of years before we enjoyed much of the fruit.

The war years were hard, especially for families with sons serving in danger every day, but on the home front, we learned to live in a very sustainable way. Approximately 40 percent of all the vegetables grown in the U.S. came from Victory Gardens. We as a nation recycled everything and we cooked slow and ate healthy. It is too bad that we haven't retained some of the lessons learned during those times.

Summer of '42

I was first introduced to Maine during the summer of 1939 when we went to Deer Island on Moosehead Lake. The next summer we repeated our Moosehead adventure. I was certainly hooked on Maine and so my folks investigated the possibility of my going to a Maine camp in the summer of 1941. They found Camp Gregory, a camp for boys aged seven to sixteen. The camp was operated by the Roman Catholic Diocese of Portland and attracted kids from both Maine and southern New England, according to the material they received. The camp was physically located on the shores of Crystal Lake in Dry Mills, a small community next to Gray, Maine, and about 25 miles from Portland. The camp itself comprised about 30 acres, much of which was wooded. The campus included a large athletic field with a both a baseball diamond, basketball court and a canteen that was open each evening so kids could purchase an ice cream, soda or candy bar. There was a 15-cent spending limit for each day. There were also a group of buildings including an administration center, infirmary, dining hall and an assembly hall that also served as a chapel for Mass. The actual camp sites were open-air buildings on stilts that had bunk beds and a rolled canvas on each side that could be dropped if it rained. Each site held ten campers and every third site had a counselor. There were two swimming areas and kids were assigned to areas based upon their swimming ability. "Class A" swimmers could use a raft with a high and low diving board.

Camp periods were divided into two-week sessions at a cost of $25.00 for room, board and use of all of the camping facilities. I stayed for two sessions in 1941 and returned in 1942 for another month.

The summer of 1942 was to be a different one, as America was now a nation at war. The full impact of the war on the home front had not yet been felt. Food and gas rationing had not been put in place, so for me, going back to camp seemed like a totally normal summer event. I hoped that I could again bunk in the same camp site with the two friends that I had made during the 1941 season. My two camping buddies were Tim Mcmanus from Portland and Charlie Sheehan from

Bangor. Over the winter, my mother had corresponded with their mothers, so I knew they were going back to Camp Gregory and that I'd meet up with them on our first day. I was certainly excited on our drive up to Maine, anticipating another fun camping experience with my friends. On our arrival we checked into the camp's administration office and found that the Sheehan's had arrived earlier than us and had requested if the senior counselor could assign Charlie, Tim and I to the same camp site. Thankfully for us, he agreed that we were again to camp together.

Our first order of business was to take our duffel bags, stuffed with a heavy blanket, pillow, pillow case, bath towels, socks and underwear, poncho, swimming trunks, shorts and tops and toilet articles that our mothers had all marked with our names, take them over to our camp site and get settled in. By around 3:00 p.m. our parents had said goodbye and left the camp. Our parents would come and visit us each Saturday. My mother and dad would spend each Saturday night in a cabin over in Naples on Sebago Lake, rather than drive all the way home to Brookline late in the day.

During the summer of '42 we were still considered at the camp to be in the midget group even though we had all qualified as Class "A" swimmers and were able to swim and dive off the two diving boards as well as use the canoes. The camp had a fleet of large Indian War Canoes and we had fun trying to push a group that we had challenged into the drink. Sports and fun activities made each day pass very quickly.

The food at camp was quite good. Breakfast each morning consisted of oranges and bananas, and small boxes of cereal—corn flakes, rice krispies and bran flakes. Pitchers of milk were on the table and you could have as many glasses as you wanted. Like any institution, the menu was repetitive for each day of the week—Wednesday's main meal was always pasta, Friday we had fish, Saturday was beans and franks and Sunday was a chicken dinner with ice cream for dessert.

Our counselor for the summer of '42 was a young man by the name of Leo Link. He was from Indiana and a student at Notre Dame. Camp days were well regulated into time segments and monitored pretty closely by counselors. Each morning we awoke to a bugle's revelry, next a brief dip in the lake. After dressing we went up to the field for flag raising and then on to the chapel for daily Mass. We then trekked down to the dining hall for breakfast. After breakfast we had chores to do at our campsite followed by games and a short swim. Lunch was at high noon. After lunch we had a rest period. During the afternoon we had options to either play sports or engage in crafts. About mid-afternoon we had another chance to swim and boat. Next came dinner. After dinner we went up to the ball field to either play or watch the older boys play. Naturally we went to the canteen for a cold drink or an ice cream or both. At dusk there was always some kind of program—movies, campfire stories, entertainment—a Penobscot Indian

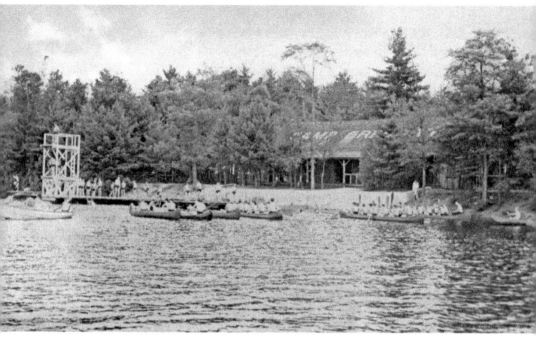

Fun at Camp Gregory.

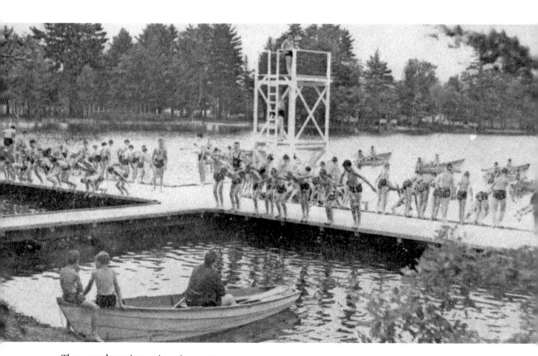

The camp's senior swimming area.

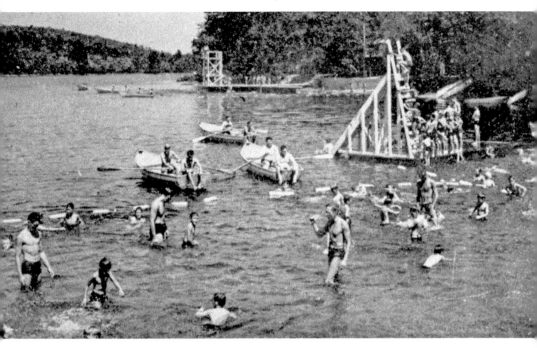

The designated area for junior swimmers.

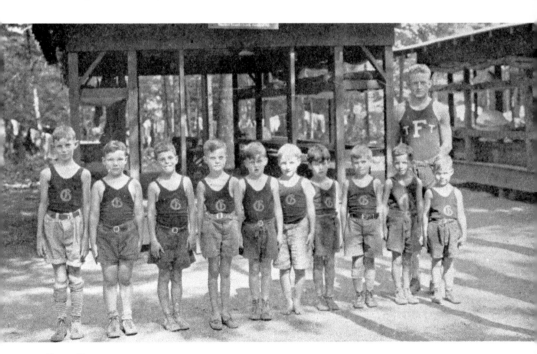

Camp Gregory campers.

told us stories of his people and another night a local country singer provided us with folk songs of Maine. Then it was taps and lights out.

One very hot day, I had the opportunity to go on a five-mile hike. I remember I had really wanted to be chosen to go on a long hike, but I would not have picked the hottest day of the year for my hiking adventure. I was very happy when we returned to camp and could go for a swim.

My mother and dad would arrive for a visit each Saturday afternoon around 2:00 p.m. One weekend they came with Mr. and Mrs. Harry Gleason. Mr. Gleason had recently purchased an Oldsmobile and let my dad drive it up to Maine. It had automatic transmission with a trade name of Hydramatic Drive—my dad loved it and wanted to get one but the war effort had cut of any additional car manufacturing. Thus, we kept our 1935 Dodge until after the war.

Another weekend they came up with Mr. and Mrs. Joseph White. The Whites were from West Roxbury and Mr. White was a Boston City Counselor. They had a son, Kevin, at camp. He was a year older than me and was camping in a different section. I only knew him as a very good baseball player. As an adult, he was to become a mayor of Boston.

On my last day of camp for the season, my dad showed up to take me home. He had come with an attorney friend rather than with my mother. After saying farewell to my camping friends and Leo Link, we loaded up the car with my gear and started on what I thought was our ride to Brookline. Little did I know what was in store for the remainder of the summer of '42.

After driving for a while and having not passed Portland or other familiar landmarks that I knew from my trips to Maine, I asked my dad how we were going home. He told me he wanted his friend to see a piece of Maine and New Hampshire that he had never seen and it was just as short. When we arrived over in New Hampshire, we were in a mountainous region and Lake Winnipesaukee. We drove along beside the lake until we came to a side road that my dad said had some points of interest that he wanted to show his friend. About a couple of miles down this side road, we pulled into the driveway of an old New England-style farmhouse. I was totally surprised when my mother came out to great us.

This country farmhouse was located in East Alton and belonged to my pediatrician, Dr. Richard Ely. He was also a specialist in tropical infectious diseases as well as being a pediatrician and was a Lt. Commander in the Navy Reserve. Right after Pearl Harbor, he was called up for duty. My folks had become friendly with him and he offered to rent our family his vacation home as he was unable to use it.

Not only was my mother there, but so was my grandmother, my dad's friend's wife, our dogs Brownie and Spot, as well as Buffy, our Maine Coon cat. Naturally, I was delighted to see everyone.

The farmhouse was quite large and had a deck on the back of the house that ran its length. From the deck you looked down to a pond on the property and in

Our August 1942 vacation at Dr. Ely's farmhouse retreat.

the distance were the White Mountains. Dr. Ely was a Virginian and had a special love for his southern heritage, the University of Virginia, as well as a fondness for Edgar Allan Poe and *The Raven*—his vacation home's décor reflected this.

My mother had brought our movie projector and portable phonograph machine to provide some entertainment during our vacation. Days were spent picking blueberries, hiking in the woods, fishing in the pond from an old row boat, swimming and taking drives in the region, and on clear nights, star gazing from the deck.

My mother hung an old sheet about once a week to show movies. Most of the movies were ones that had been taken on previous vacations but one was a comedy about a monkey that she had bought and which I enjoyed seeing. The portable phonograph (which all the adults called a Victrola) had to be wound up each time to play one record. The records I remember we had that summer were: *At Last, There'll be Bluebirds Over the White Cliffs of Dover* and *Tangerine.*

My dad was able to vacation with us the entire time that summer we were at East Alton. We stayed until Labor Day and then it was back home and return to another year at school.

I never returned to Camp Gregory nor did we have an opportunity to rent the East Alton farm. Over the years I lost contact with my camping buddies. I learned many years later that Charlie Sheehan had become a Navy aviator and been killed in a crash out in the Pacific.

Summer of '42 still remains a fond memory.

Autumns Remembered

When I was in the lower grades at the Runkle School, we boys started the school year garbed in our summer shorts. Come October 1, our mothers, like military commanders, ordered us into our winter uniforms, which consisted of corduroy knickers, knee socks and Eaton caps. It seemed that the first few days after donning our winter attire, the weather always turned warm. As we approached Columbus Day, the nice autumn days and crisp nights turned the foliage of our area into a blanket of brilliant yellow, orange and red hues. The conversation we kids heard from our parents was centered on the awesome beauty of that year's foliage. We boys were a lot more interested in when this colorful blanket would turn into a carpet covering the lawns of our neighborhood and then raked into piles that we could tramp through and wrestle in. As luck would have it, we always managed to have a soaking rain, which emptied the trees of their leaves and set up the stage for several weeks of fun. My best friend Randy and I wrestled our way home from school, stopping at every large pile of leaves and rolling through this wonderful carpet of fun. This fun would soon go up in smoke, as everyone then burned their foliage collection. The aroma of leaves burning still remains in my sensual memory. I don't know if it was fire laws or EPA regulations that put an end to this autumn ritual.

October 15 was my birthday, which I relished for the gifts I received and the special birthday meal that my mother always prepared, which naturally included a cake and ice cream.

Halloween was the next big event on the autumn calendar. All of us kids enjoyed helping to pick out the right pumpkin. When we had our Victory Garden we had one pumpkin hill and ended up having several choices as to which one would look the best carved out and lit for that special night. Costumes were much more simple back then; a ghost costume was quickly produced from an old sheet, one was easily transformed into a clown or a hobo by way of some old tattered clothes and some of your mother's make-up, while some kids had cowboy and policeman uniforms and donned them for their trick or treat foray

through the neighborhood. When I returned home, my mother would sort out the candy loot collected and let me enjoy some of that night's collection but save most out for future treats.

I only went to one Halloween party as a kid. My cousin, Peggy Ann, hosted it, when I was seven or eight. There were about ten kids in attendance, mostly all girls. I know we dunked for apples and ate a lot of candy.

November 1 was All Saints Day and a Holy Day for Catholics. This meant an early rise that morning, a trip to the Franciscan Friary for an early Mass and then back home for breakfast and school. On my return home from school on that day, my mother started her holiday calendar ritual, which meant that each day I was to be given a star to track how good I had been. A gold star indicated that I had been very good, a silver star for a fair day in the behavior area and a red star meant much more was expected of me. A tabulation was made and just before Christmas a report card was sent to Santa.

As we moved on towards Thanksgiving, we kids on Sumner Road spent our afternoons playing football in the gym yard. As the days became short, our football playing ended earlier and we went home to listen to our favorite late afternoon radio shows.

November 11, then called Armistice Day, as it marked the end of World War I, also marked the end of the growing season. I was given the job of helping my dad clean out our two Victory Gardens. The only remaining crops at that time were some root vegetables, carrots, beets and turnip, which we dug up, and a row of banked celery, which we would wait until near Thanksgiving to cut.

Thanksgiving officially ended autumn for us and signaled the start of the holiday season.

Valentine's Day Storm

It is almost a lifetime ago when I was a third grade student during the winter of 1940 at the John D. Runkle School. Miss Shirley was our teacher and my best friend, Randy Filmore, was a classmate. Miss Shirley stands out as one of the best teachers that I ever had, as she had that special gift of making learning fun for each kid and by challenging the class to do exceptional things. There were 30 kids in our class, broken into five rows, six kids to a row. Miss Shirley made each row into a team—The Bears, The Lions, The Tigers etc. and each day she would pick a captain in each row for the day. Everyone during their grammar school days participated at some time in spelling bees; we had these but we also had arithmetic bees. These involved mentally adding, subtracting, multiplying and dividing quickly, with no paper and pencil help. Calculators and iPads were not known at that time.

We were all told that Valentine's Day would soon be coming and that all the boys should make valentines for all the girls in the class and the girls should make valentines for all the boys. In that era, you went to the 5- and 10-cent store and bought a Valentine Card Kit. As long as you had a pair of scissors and some glue, you were all set to work on this special project. Each student was to bring his or her valentines in on Valentine's Day and place them in the Valentine Box. Usually, the teacher would select a girl or two girls to make the Valentine Box but Miss Shirley didn't follow the traditional norms, and for Valentine's Day 1940 she selected Randy and I to handle this special assignment.

When Randy and I told our mothers, they were surprised but agreed to help us with our project. My mother said we could use one of her big hat boxes and Mrs. Filmore volunteered the paper. We intended to work on the project over the weekend and bring the finished Valentine's Box into school on Monday, February 12.

The winter of 1940 had been rather cold but not snowy, as we had not had any snow days off from school. Mr. and Mrs. Sullivan, neighbors who lived in the large white two-family house on Blake Road facing down Sumner Road, were avid skaters. They did not have children and were very kind to both Randy and I. This winter they had taken us several times skating up at the reservoir, and on

one Saturday afternoon to watch a group of ice sail boats race their boats up and down the reservoir.

On Monday, February 12, we proudly brought our completed Valentine Box to school. Miss Shirley complimented us on our job and said that everyone could start bringing in their cards on Tuesday.

On Tuesday morning, we went to school in our sneakers, as it was a gym day. When we arrived home from school, we received a message from our mothers that Mrs. Sullivan had called and invited us to go with her over to Coolidge Corner. Naturally, we both jumped at the opportunity as we knew from past experience that this also meant a trip to Brigham's for an ice cream Sunday. At about 2:30 p.m. Mrs. Sullivan honked her car horn and we raced out and piled into her big Buick. She said that she thought that we might like to get our mother a Valentine present at S. S. Pierce's. Just as we arrived at Coolidge Corner it began to snow. We went into the store, and both Randy and I purchased a small heart shaped box of candy for our Mothers. When we reached the car there was better than an inch of snow on the ground. Next, Mrs. Sullivan asked us if we would like to go to Brigham's—we had guessed that would be part of her plan and were thrilled. As we drove up Beacon Street, the snow kept coming down faster. We went into Brigham's and enjoyed our favorite raspberry ice cream with strawberries and whipped cream. After finishing our special treat, we ventured out into what had developed into a blizzard. By the time Mrs. Sullivan dropped us off we had nearly six inches of snow on the ground.

The snow and drifting continued all that night, bringing life to a halt in Brookline and Boston. Obviously, Valentine's Day was a snow day for all the kids of the area. There was also no work for most people, as public transportation had been suspended due to the storm. My dad checked outside on our porch to see if the morning papers had arrived, but no such luck.

Dad relied on Boston's radio station, WEEI, for his local and weather news that day. Boston's iconic weatherman, E. B. Rideout, reported that the storm had dropped more than a foot of heavy wet snow on the area and that wind gusts of more than 50 miles an hour had caused drifts of up to five feet in spots. The local news anchor followed up by saying it would take several days for the area to dig out from this massive storm.

Mother prepared breakfast, which was a rather leisurely one, as no one had to rush out to school or work. She said that for breakfast, we were going to have grapefruit and I was going to have hot oat meal, toast with apple butter and milk. Dad wanted his traditional weekday breakfast of two soft-boiled eggs, toast and coffee. I'm not sure what mother was going to have that morning.

My excitement over the snow storm almost made me forget that this was Valentine's Day. I came to my senses when I saw that mother had placed cards at both my place and Dad's. Next, I went into the living room and told Dad about the cards and then I ran upstairs and got my mother's card and her candy heart present. Dad beat me to the dining room table with his card and gift. Soon we all sat down for breakfast and to enjoy our Valentine's Day together.

Our house after the Valentine's Day snowstorm.

After breakfast we went into the living room and Mother put on the radio for her favorite morning program, Don McNeill's Breakfast Club show from Chicago. The show was broken into four segments called "four calls to breakfast." Each of these segments would start by calling for a march around the kitchen table to music; Mother and I marched around the living room at each segment.

About mid-morning, Randy's dad called to tell my dad that the garage area and driveway would not be shoveled out until the afternoon, as the snow had drifted quite high. We did not have a garage and rented a section of the Filmore's garage for the hefty sum of $5.00 per month, which included shoveling if required.

Looking back, although I had no concept of it as a kid, the year 1940 was truly a transitional year. It was a time when the decade of economic hardship from the Great Depression was starting to ease and men like Randy's dad were starting to get better jobs at Boston's Navy Yard, and the older boys of our neighborhood were still home and in school. December 7, 1941, was still almost two years away.

Before noon, Dad called the Ryans and asked if their son, Ed, would be interested in shoveling our walk. They told him that Ed would love to do the shoveling and would be over after lunch. Ed was a senior at Brookline High and was going off to college in the fall. Little could anyone think then that in a few short years, Ed Ryan, from across the street, would be piloting bombers over Germany. As an eight year old that February, my mind was totally locked into having fun in the big snow storm that had blanketed our area.

When the walkway was cleared, Brownie, our Welsh terrier, and Spot, our Wire Fox terrier, were able to get out in the side yard. They both loved playing in the snow but were happy to come back into the warm house and get a treat.

Randy, Spot and I on our
front lawn.

On Thursday morning, February 15, we turned on old reliable WEEI for the latest in local news and weather. When I heard "No school, all schools, all day," I was delighted that I would have a day to play outside, and perhaps coast and make a fort.

Mother fixed breakfast for us all. Then Dad left for his office and walked down to catch the morning train to Boston's South Station. Work certainly wasn't called off that day. Mother and I went into the living room to once again hear Don McNeill's Breakfast Club show. I think that day we marched around the living room to all four calls for breakfast.

After lunch, I connected with Randy and two other neighborhood boys, Dick Carerro and Herby Meehan. We agreed on a plan to build a large fort on Blake Road near the Sullivan's house. The afternoon went by fast as we shoveled and molded the heavy wet snow into blocks. By the time the sun was starting to set, we called it quits for the day.

Yes, there was school on Friday, February 16. This was to be the re-scheduled Valentine's Day and when Randy and I arrived in our classroom, we saw that all had remembered to bring in their cards. Miss Shirley told us after the pledge of allegiance and short Bible reading that the Valentines would be delivered. She then appointed one of the girl's to be the post mistress. When it came time for the Valentines, she unveiled two trays of goodies for us to enjoy. I think everyone loved the belated Valentine's Day celebration.

When we were going to lunch, the principal announced that large metal trays were available for coasting on the playground.

Friday was certainly a fun day at school. I knew that our Washington's Birthday Vacation was just around the corner and with all the snow on the ground, I looked forward to having a wonderful time.

Mother's Surgery

It was the summer of 1943 and my mother was having gall bladder attacks on an ever-increasing basis. It became obvious that she was going to need surgery. A short few days after July 4, she had an appointment with Dr. William Browne, chief of surgery at Boston's Carney Hospital. He told my mother that her attacks would continue to occur until she had her gall bladder out, and that he could schedule her for surgery in early August.

It was countdown time from that day in July until she was to go to the hospital. The Carney Hospital in those days was still in South Boston, where it began in the mid-19th century. In those days, gall bladder surgery was a big deal. My mother would be kept in the hospital for about a week. After her release to go home, she would have a drain and be bedridden for another week or ten days. I know that she was scared about going in for the surgery by the way she avoided talking about her upcoming event.

She was most concerned as to where I'd be during her hospitalization and when she first came home. A plan was drawn up for me to spend the first week while she was in the hospital with my Aunt May (Mother's sister), Uncle P. J. and cousins Ed and Mary Lou, and then the second week with my Aunt Margret (Dad's Sister), Uncle Billy, cousins Peggy Ann, Bill (Junior), Mary and Grandma.

On Sunday, the day before her surgery, my parents took me to Aunty May and Uncle P. J's house in Newton Centre. After a brief visit, they left to drive over to the Carney Hospital, as my mother had to be checked in the day before her surgery. We had Sunday dinner around 2:00 p.m. and shortly after that, Uncle P. J's brother, Frank, and family arrived. They brought with them a special present, a Mastiff puppy. She was four months old and a bundle of fun. She was to be named Duchess.

During the week that followed, Mary Lou and I played and tried to teach Duchess to walk on a leash. Her favorite pastime was knocking over her water bowl. Leash training was not accomplished during my stay. I didn't see much of my cousin, Ed, as he was in his second year at Tuft's Medical School and was involved with medical work most of the time.

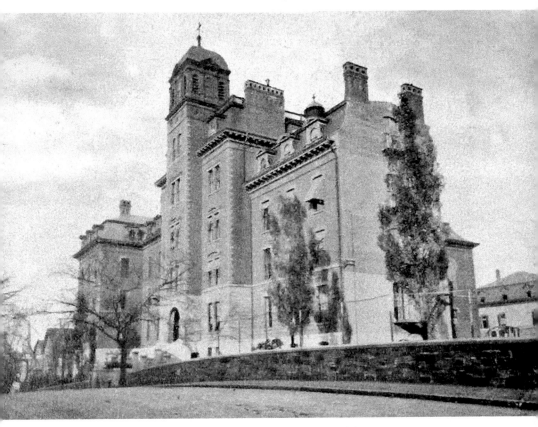

The old Carney Hospital in South Boston, where my mother had her surgery.

Uncle P. J. Craffey with a full-grown Duchess in the late fall of 1943.

On Monday afternoon after my mother's surgery, Dad called to tell both Aunty May and me that the surgery had gone well and Mother was back in her room resting. He planned to go back later in the day to see her and he would keep us posted on her condition. For the rest of the week, he called us twice a day to give us progress reports.

Early on Saturday morning, Dad picked me up. He brought with him another small suitcase for me, with clean clothes and two bathing suits that Mother had packed for my second week, which was to be at the beach. We said our good byes to Aunty May, Uncle P. J., Mary Lou and Duchess and started on the road to Grandma's house in Brookline. Dad stayed a short time but wanted to get over to the hospital to see Mother, and everyone was anxious to get going to the beach, as that Saturday morning was a hot one. Two cars were to make the pilgrimage to the cottage that Aunt Margret and Uncle Billy had rented at Rocky Nook, a south shore beach community near Plymouth. Aunt Margaret, Uncle Billy and my cousins all went in Uncle Billy's car and Grandma and I rode with Uncle Bill. Uncle Bill was just going for the weekend, as he had to be back to work at the post office on Monday. It was a relatively short ride to the cottage, and after we brought all the luggage and food in, we donned our bathing suits for a swim before lunch.

The week was very hot and we all spent a lot of time at the beach which was just across the street from the cottage. Grandma stayed out on the porch each day, as her arthritis was quite bad and she couldn't make it down to the beach. Uncle Billy and cousin, Bill (whom everyone called "Junior," as there were three Williams/Bills in the house) took turns bringing up buckets of ocean water for Grandma to soak her feet, which they thought might give her some relief.

In addition to swimming out to the raft and walking the beach in search of treasure, we played horse shoes in the backyard of the cottage. Uncle Billy was a real pro at the game. I thought it was fun but never became very good at it.

The conversation between Peggy Ann and myself was about starting back to school in a couple of weeks as summer was winding down. Peggy was going into the 7th grade, while I would be starting 6th. Junior had graduated that spring from Brookline High School and was very excited about starting college at St. Michael's in Vermont in about 10 days after we left the beach.
The only downside to my week at Rocky Nook was a bad sun burn. I think I was sore for about two weeks.

I returned home after being away two weeks. I was really surprised at how weak and poorly my mother looked. She was not up to doing much and thankfully, her friend Catherine "Caddi" Clarke volunteered to spend a week helping out with the cooking and housework.

On Monday morning, my second day home, I went with my neighborhood buddies down to the Cypress Playground to play ball. It was there that I met up with a classmate, Ned Dalton. He told us that his dad, who was a dentist,

had been called into the service and that he and his family were going to be moving away that week. He had two pet white rats, Oscar and Minnie, that he was not going to be able to keep and he then offered them to me. I jumped at the opportunity, as I always loved having various pets. That afternoon I went up to Ned's home, which was on the corner of Boylston Street and Clark Road, to pick up my new pets. Ned gave me quite a bit of food for them and some instructions on their care. He kept them in a small wooden cage with screening. It had a door that lifted in the front. Naturally, I took them out and played with them while at Ned's. Next, I said goodbye to Ned, thanking him for Oscar and Minnie and telling him I would take good care of them. I also wished him good luck in his new school and hoped that he would soon be back in Brookline.

I then walked home with my new friends. Upon my arrival, I showed Oscar and Minnie to "Caddis" who certainly was not excited about seeing my new pets. She thought that they were mice and didn't understand why I wanted them for pets. I shrugged off her comments and went upstairs to show them to my mother, who was resting in bed. I took my friends out of their cage and showed them to Mother, who screamed when she saw them crawling around my neck: "Get them out of here! I'm going to tell your father when he comes home about those rodents that you have."

Keeping her word—mother told Dad. He actually laughed when he saw me and told me to just take care of them and keep them down in the cellar out of sight of my mother.

Mother's health improved and Oscar and Minnie stayed in their new home downstairs in our cellar's laundry room.

Those Radio Days

There was a time when news, entertainment and sports weren't watched on a tv screen, computer, iPad, tablet or smart phone, but came magically through the air into a speaker on an electronic device called a radio.

I grew up in those days of radio. As I remember, we had two radios, a large console in the living room and a smaller one on a night stand in my folk's bedroom. In the late 30s my dad bought himself a portable unit so that he could keep in touch with the news when on vacation, and when I was in the 3rd or 4th grade, I was given a small radio for my room.

The radio certainly played a major role in our everyday life. I heard the radio go on first thing in the morning in my parents' bedroom, as Dad would have turned on WEEI, Boston's CBS affiliate, to listen to the local news and weather. E. B. Rideout was the weatherman, who would always report what was happening in the weather department from Eastport to Block Island. In between news and weather, a local musical duo, Hum and Strum, would provide a few ditties. Naturally, during the winter months if it was snowing, my ears were keenly tuned to hearing the notice: NO SCHOOL ALL DAY IN BROOKLINE PUBLIC SCHOOLS.

Boston had a number of radio stations in addition to WEEI. These were: WBZ, WHDH, WNAC and WCOP. Back in the late 30s and early 40s all of these stations were AM only; there were no FM stations until much later. After school in the fall and winter when I was at home, I listened to three afternoon programs: Jack Armstrong, "The All American Boy," as I recall he had several friends; Billy, Betty and their Uncle Jim who was always going off to some exotic place on business and then getting lost and needing Jack and the crew to find him. Wheaties "the breakfast of champions" was the show's sponsor. Next came Captain Midnight, sponsored by Ovaltine. I had my mother buy some, so that I as a member of the Captain's Secret Squadron could secure his secret decoder and decrypt his special messages. The last of these late afternoon shows was Terry and the Pirates.

The evening news was a must event for my dad. Although we received two morning papers, *Boston Post* and *Herald*, and two night papers, *Boston Globe* and *Record-American*, he enjoyed both reading and hearing as much news as he could get. Today, he would be called a news junkie. During the war years, his favorite radio news anchors were H. V. Kaltenborn and Edward R. Murrow. It seemed to me that H. V. Kaltenborn started his broadcast each night with either "There's good news tonight" or "There's bad news tonight," depending how the war had gone that specific day. Edward R. Murrow, the voice from London, would make you almost hear the bombs hitting a target near the station by his vivid description of what was occurring around him.

After the evening news, the Lone Ranger came to life with his faithful Indian companion, Tonto. These brave western heroes tracked down outlaws for decades. The William Tell overture officially announced the show with the announcer doing a voiceover the theme music—"From out of the past came the thundering hoof beats of the great horse Silver, the Lone Ranger rides again." I think the legend of that masked hero, his horse, Silver, along with Tonto and his horse, Scout, are icons of the golden days of radio. The show was sponsored by KIX cereal. I had my mother buy some so I could send in a box top and at get a Lone Ranger ring with a military insignia of the Army, Navy or Marines. The

Week nights, after the evening news, the Lone Ranger came to life with his faithful Indian companion, Tonto, to track down gangs of outlaws. Publicity photo of the Lone Ranger and Silver actor, Clayton Moore, at Pleasure Island, Wakefield, Massachusetts.

top of this wonderful ring could be slid off so secret messages could be hidden in it. I sent in the box top with a request for a ring with the Navy insignia. I was super excited when it came in the mail. The following day after school, my best friend Randy and I started up to the Cypress Spa for an ice cream. We took a short cut, and as we went up a wooden stairwell to Cypress Street, I showed Randy how the secret compartment of my new ring worked. It slid off and went down through a crack in the stair, never to be seen again. I was heartsick over my loss.

My mother had her set of favorite radio programs. In the morning, she would listen to Don McNeill's Breakfast Club. On days when I was home from school, I would listen to the show with her and every quarter hour, there would be another call for breakfast that required a march around the kitchen table. Since we were in the living room, we marched around it. Sunday evening during the early 1940s was a time when families tuned into Fred Allen and Allen's Alley and to the Jack Benny show. My dad enjoyed hearing Walter Winchell, who followed Fred Allen and Jack Benny. He always began each program with "Good evening Mr. and Mrs. North and South America and all the ships at sea." Mother's favorite show was the last one we listened to on Sunday—"American Album of Family Music" starring tenor, Frank Munn, "the Golden Voice of Radio" and Soprano, Jean Dickenson, "Nightingale of the Airwaves." Mother enjoyed musical programs the most. Among her show choices were: Irish tenor, Morton Downey, Kate Smith, Bing Crosby and Major Bowes "Amateur Hour."

Above left: Irving Berlin's "God Bless America" was made famous by Kate Smith during the War Years. Her weekly radio program was one of the most popular during that era.

Above right: Every Sunday evening we listened to Fred Allen and his Allen's Alley.

Several quiz shows were popular during the 1940s. Among those we often listened to were "Dr. IQ." This program originated in a theater in a different city each week rather than from a radio station. Dr. IQ would have his assistant wander through the audience to find contestants. The top prize for the most difficult question answered was $64.00 and contestants that did not give a correct answer to a question received a box of Snickers. "The Quiz Kids" featured kids on the program from around six to sixteen; each kid received a war bond for participating. Another show "It Pays To Be Ignorant," was a radio comedy spoof of Dr. IQ. This show had a board of so-called experts that would be challenged by questions like, "who is buried in Grant's tomb?"

Other shows that we listened to were: "Fibber Magee and Molly," "The Great Gildersleeve," Fanny Brice as "Baby Snooks," "Inner Sanctum," "The Aldrich Family" and "Mr. Keen Tracer of Lost Persons."

On the local sports scene, we listened to broadcasts of Red Sox and Braves games. Bump Hadley, a former major leaguer, helped announce home games and also did a nightly sports update. In the late 1940s, Don Kent became a local radio weatherman. I remember quipping how many flurries I had to shovel as

On the local sports scene, Bump Hadley, a former big-league ball player, helped announce home Boston Braves and Red Sox games, as well as broadcast a nightly radio sports update. In this photo are NY Yankees Johnny Murphy and Irving "Bump" Hadley at Fenway.

Fanny Brice as Baby Snooks was a radio show we enjoyed listening to on a regular basis.

result of Don's forecast. Over time, he moved on to TV when it arrived on the Boston scene.

Radio, like print media, required one to visualize. This was never an issue for my generation. Today's kids, with all of the visual media available to them, have not had the opportunity to engage in the visualization process.

A Special Thanksgiving

My mother loved to cook and entertain. Thanksgiving was an occasion that certainly provided her with a great opportunity to fulfill her culinary and hostess gifts. Every Thanksgiving, Grandma, Uncle Bill, Aunt Margaret, Uncle Billy and my cousins, Mary, Junior and Peggy Ann, joined us for the annual feast; on Christmas we reversed roles and went to Grandma's for the yuletide dinner.

Planning and logistics always played a major role in my mother's preparations. She had to worry not so much about the task of preparing the meal but what the weather was to be, where the Brookline High-Newton High traditional football rivalry game was to be played since many family members always went to the game, and if the weather was bad, and it was played in Newton and the dinner schedule had to be moved out an hour from 2:30 p.m. to 3:30 p.m. This created a secondary problem as my bachelor Uncle Bill had two girlfriends that he had to join for dessert. He obviously had to tell each a different story as to when his family's dinner was so he could keep his dates. My mother needed to keep Bill's love life issue in mind as the game situation became clear.

Thanksgiving 1943 was even more complex than usual, as it was during World War II and just about everything was rationed. We traditionally started our Thanksgiving feast with a fruit cup cocktail appetizer but Dole's canned fruit cocktail was very scarce and required a number of ration stamps. Mother prepared for this contingency by stocking up on a can in August and another in September, which allowed her to focus on getting cranberry sauce in October and early November. Getting a turkey posed no problem, as Mother's cousin, Tom Brennan, operated a poultry farm in Oxford, Massachusetts, and my dad bought Tom 100 baby chicks and 50 turkey chicks each year. In turn, we received a weekly delivery of farm fresh eggs and poultry. We had a large Victory Garden and had harvested lots of onions and turnip that were stored in a vegetable bin in a hallway off the kitchen, and in the cellar was stored a large blue hubbard squash, as well as several shelves of canned vegetables, including string beans that my mother had put up during the summer. We always had as part of our

traditional turkey day feast celery and black olives. The olives my mother was able to get at the store and I don't remember whether they were a rationed item or not, but the celery we had in the garden. In those days, folks wanted their celery bleached, so in late September, my dad showed me how to do that and keep the celery fresh and from freezing. We banked the row of celery on each side with a 2 × 4 and hoed dirt up against the 2 × 4s to hold them in place, while the top we covered with straw to keep out frost. My job on the Monday before Thanksgiving when I came home from school was to go out and open up the celery bed and pick it for the holiday. The celery had stood up well and was ready for our upcoming feast.

Because of the war, many servicemen were not able to be home for Thanksgiving and a call went out in either the Boston newspapers or on the local radio for families to consider inviting a serviceman or two to join them and make them feel at home for the holiday. My mother responded to the request and said we would be happy to host several servicemen. I believe she had to tell the coordinator of the program specifically where we were located, public transportation that was available and when the invitee should arrive. As I recall, the coordinator got back to my mother on the Friday before Thanksgiving thanking her for her kindness and informing her that they had four invitees for us. They included an Army 1st Lieutenant that was stationed at the Boston Army Base, an Army Sergeant and his wife, who had just arrived that week for his new

Dad cultivating the garden.

duty at the Army Base, and a Sailor who was posted at the Navy's Boston Fargo Building.

The inclusion of the service group made the total for the Thanksgiving feast to be fourteen, counting everyone. My mother decided not to tell the rest of the family and let the expanded guest list be a surprise.

Wednesday before Thanksgiving saw my mother starting her cooking routine at the crack of dawn. Luckily we had two stoves in our kitchen, a gas one and an old wood stove that had been converted to kerosene. Thus, she could have a number of different things going at the same time (multi-tasking was not a term used in those days). I had a half-day at school, so when I arrived home, Mother had a list of jobs for me to help her with. She didn't think two cans of fruit cup were enough with the expanded guest list, so she thought she could stretch the appetizer by adding a small scoop of sherbet, which was not rationed. Thus, my first job was to run up to the A&P on Cypress Street and acquire a quart of Hood's orange sherbet. After completing that task I was to go to the cellar and bring up the large blue hubbard squash and several jars of canned string beans. The aroma of cooking was wonderful, especially the smell of apple pie baking. Our dog Brownie was going crazy, as he knew if he hung around the kitchen he would receive all kinds of treats. The two turkeys that cousin Tom dropped off were about eleven or twelve pounds each. Mother had a traditional dinner but did explore new dressings. This Thanksgiving, one turkey was to be stuffed with a standard bread stuffing, while the second bird would have a potato and sausage stuffing. By 5:00 p.m. on that Wednesday, my mother had cooked all of the vegetables, so all she had to do on Thanksgiving was warm them. The two turkeys were ready to go into the oven so that Thursday morning could be devoted to decorating, setting the dining room table and any other last minute tasks.

Dad had ordered mums from Joe Alfuso's Station Flower Shop that were to arrive Thanksgiving morning. My mother asked Dad about having a fire in the fireplace, but he nixed it as a bad idea, as with so many folks in the house it would be too hot.

The morning passed into afternoon and at about 1:45 p.m., our first guests, the Army Sergeant and his wife, arrived. By 2:30 p.m. everyone had arrived and been introduced to one another, and were set to enjoy a very special Thanksgiving feast. After grace was said we all had a great meal together. Mother received a nice thank you note from all of the service members who joined us. We never knew how either the Lieutenant or sailor faired during the remainder of the war, but the Sergeant's wife kept in touch for years, even after they returned to civilian life in St. Louis, Missouri.

I guess no news was good news relative to Uncle Bill's love life, as my mother received no feedback relative to his dessert dates.

North Country Trip

Shortly after school finished in June of 1944, my dad told me he had to make a trip to northern New Hampshire and Maine to take depositions from a number of people who had been injured in a bus accident during the winter of 1942. My dad was chief claims attorney for the Massachusetts Bonding and Insurance Company, who were the insurer of a large regional bus company, whose bus had gone off the road in a snowstorm. The day of the accident, the bus was on route from Portland, Maine, to Colebrook, New Hampshire. My dad had already been up to northern New Hampshire several times, taking depositions of some of the bus passengers that had not been injured. He asked me if I'd like to go with him on this forthcoming trip. I told him I'd love to go. He also said that we could get in some fishing, which made the planned trip seem even better.

Dad was a serious angler as well as a lawyer and was always ready to cast a line in a stream or pond, so I knew that our trek north would be a fun packed adventure. Dad did tell me the down side of the trip was that I would have to wait in the car during the time he was involved with taking depositions. He forewarned me that they often ran several hours, so I should pack plenty of reading material.

Dad made a number of telephone calls and set up his first appointment starting on Thursday afternoon, July 6, with a woman who had been injured that was from Whitefield, New Hampshire. He thought the trip would take about ten days. I was excited and started collecting books, including several new comic books, fishing gear, clothes and swimsuits for the long trip.

My mother's birthday was July 3, and on Sunday, July 2, my Aunt May (my mother's sister) and Uncle P. J. Craffey, invited us for dinner to celebrate her birthday. On her actual "B" day we went out to a nice dinner at Tolino's Italian Restaurant in Chestnut Hill. We later had ice cream and cake at home. On July 4, Declaration Day, we went to a parade up on Boylston Street and watched several bands, World War I members of the local Legion and VFW posts and a few Spanish-American war veterans marches; a war bond float and several fire

engines rounded out the event. I enjoyed all the celebrating but I was actually more interested in what lay ahead on our trek to the North Country.

Thursday morning, July 6, finally arrived. We had packed the car the night before with everything but a picnic lunch that my mother had made for us. We needed to leave by 9:00 a.m., as it was a long drive from Brookline to Whitefield, New Hampshire, and Dad's afternoon appointment. In those days, there was no Route 93 North, just old Route 3. We did manage to get started right after breakfast. The drive would take us across the old Cottage Farm Bridge, through Cambridge and up Route 3 to Chelmsford and Lowell and into Nashua, New Hampshire. We continued our push north and around noontime, Dad saw a sign for a picnic area up ahead and decided it would be a great place to stop for our lunch. The specific location was just above Concord. We had our picnic and moved on toward Whitefield. Dad using his Texaco Road map (GPS was not known of then), figured we had about 100 miles of driving to go and that we should arrive in Whitefield close to 2:30 p.m. We were now in more rural New Hampshire. I could not believe the advertising signs in pastures that we were passing. There would be six signs a few feet apart; the first five signs would have a catchy verse and the sixth sign would read "Burma Shave." It turned out that we would follow these Burma Shave messages across most of our northern adventure.

We did reach Whitefield a little before 2:30 and found the home of the woman my dad was to meet with. After Dad went in for his appointment, I broke out a comic book to read. This first disposition took about an hour and a half. Dad told me that his deposition went very well and that we were now headed further north to Groveton. We were going to be spending the next two nights at the Eagle Hotel.

Groveton was about 20 miles north of Whitefield. The Eagle Hotel was located right in the center of town on Main Street. Dad had made reservations for us and he had become friendly with the owners, Emile and Mable Dupuis, from his earlier stays. The hotel was a large old grey asphalt shingled building with a long porch with a front entrance to the hotel and an entrance to a bar (called the tap room) at the other end of the porch. After checking in with our bags I met Cleo Dupuis, Emile and Mable's son, who was working the front desk. We took our bags up to our room and then came down for dinner. Emile heard we had checked in and came out of the kitchen to meet us, as he was the chef that night. He told us that Mabel was running the tap room that evening. I learned over dinner from dad that the Dupuis had bought the hotel in 1942. They had first leased the tap room and Emile had started a cab business. Before their involvement in these activities, they had both worked in the town's paper mill. The last time my dad was at the hotel, Emile was in the middle of buying a camp on Big Diamond Pond in Colebrook, and asked my dad to read the purchase agreement. My dad told him it was a pretty standard contract for camps, as you

purchased the camp itself but receive a lease from (in this case) Brown Paper, who owned the land. After dinner we sat in the lobby for a short while and then went up to bed.

After showering and dressing, we went down for breakfast. Emile joined us. He told us that the fishing had been great up at Diamond Pond and invited us up to his camp on Saturday to go fishing. My dad's appointment was over in Stark and Emile gave us directions to the street where the person lived. Before leaving town, we stopped at the local grocery store and picked up a loaf of bread, some cold cuts, mustard and two bottles of ginger ale. We arrived at the home of the individual my dad was to take his next deposition from about 10:30 a.m. Like at Dad's first appointment, I pulled out reading material. This time it was the latest Field and Stream magazine. This deposition took a little longer than the first one and Dad came out around 12:30.

It was certainly time for lunch and we wanted to find a nice picnic area. We knew from experience that both New Hampshire and Maine offered great picnic locations across their states. Dad told me that the gentleman that he had met with told him that an old CCC camp of the Great Depression had been turned into a German Prisoner of war camp and that prisoners had started to arrive there that spring. He thought that it might be interesting to see and on the way there we might find a picnic area. We found both a picnic area and the prisoner of war camp. The camp was fenced in but we could see some of the prisoners outside walking around. After our picnic lunch we headed back to Groveton. When we saw an ice cream stand, Dad asked me if I could handle a cone. That was a silly question—who couldn't handle an ice cream on a hot summer day? We both had a large black raspberry cone. Back at the hotel, Mabel was handling the front desk. She told us that Emile would drive with us up to the camp but Cleo would be going up in the late afternoon, providing Emile with transportation back to the hotel, as they had to take turns working and enjoying the camp. Mable also told us that she was excited that she an Emile had received a letter from their other son, Buddy, who was in the Navy somewhere in the Pacific and that he was doing okay.

On Saturday morning after breakfast, we started up to the camp at Big Diamond Pond. The trip took a little better than an hour. We parked the car in front of a path at the top of a hill that led down to the camp. The camp was located just a few yards back from the pond. We only carried down our fishing gear, as we would be staying at a cabin in Colebrook that night. Emile said that he'd make us some sandwiches for lunch and then we'd go out on the pond for an afternoon of fishing. After a quick lunch, we went down to the boat house and boarded Emile's large fishing boat which had a 7½ Johnson outboard motor that was more than enough power to cruise the pond. Emile took us to a spot on the other side of the pond that he thought would be ideal for that time of day. He was right. Shortly after he had cast a fly, he hooked a nice brook trout. Dad caught

One of my catches on our
north country trip.

one next and then it was my turn. We all had a lot of fun and a sizeable catch by
mid-afternoon. When we got back to the camp, Emile and my dad cleaned the
fish and I was given the opportunity to take the rowboat down to a small beach
and go for a swim.

We left our catch with Emile as we had no place to cook the fish, and headed
back to downtown Colebrook, which was about ten miles from the camp. We
checked in to a cabin on Route 3 and then went to a diner for a Saturday night
dinner of baked beans and hot dogs. Before going back to the cabin, we checked
out where the Catholic Church was and what time Mass was on Sunday. We then
returned to the cabin and sat out on the porch until sunset.

The next morning we dressed and went to Mass. After church we returned to
the diner where we had eaten Saturday night for breakfast. After breakfast we
walked to the drug store where my dad was able to get the *Boston Sunday Globe*.
We then went back to the cabin and read the paper.

The afternoon offered another opportunity to go fishing. This time, we were
going to try our luck in the Connecticut River. We had bought some night
crawlers and were going to use them for bait rather than artificial lures. On the
other side of Route 3, close to the cabin where we were staying, was a large farm
on the river. We walked down to the farm house and knocked to see if it would
be okay to trespass on their property to fish. The woman who came to the door
was very pleasant and said it was fine for us to fish on her land and wished us
luck. We baited our lines and made our casts into the fast running waters of the

Above left: Dad fishing in the Connecticut River. *Above right:* Dad standing in front of the Colebrook, New Hampshire, cabin we stayed in.

Connecticut. This was my first experience fishing in a river. Dad told me that trout were the primary fish in the river but both New Hampshire and Vermont may have stocked other species, so we were going to be in for an adventure. After a short time Dad had a strike on his line which turned out to be a nice rainbow trout. I had a bite a short time later and landed a good sized brookie. The afternoon proved to be quite an exciting fishing day. We walked back up to the farm house to offer our catch to the owners. The woman who gave us the okay to fish invited us in. She was delighted to accept our catch. She then said that she and her husband would like us to stay and have Sunday dinner with them. We accepted their invitation and feasted on a wonderful meal of homegrown beans, corn, tomatoes and roast chicken. They told us they were delighted to have company. They had two sons and a daughter. The two boys were both in the

service; their daughter was married and her husband was also in the service and stationed in Washington, where she had joined him.

After thanking this couple for their wonderful hospitality, we returned to the cabin for the evening. We listened to the radio in the room and then went to bed.

Monday morning Dad had an appointment for a deposition with a man who lived at a camp on Back Lake in the town of Pittsburg. This town was New Hampshire's northernmost community; it also was the location of the three Connecticut Lakes and headwaters of the Connecticut River. Just over the border from Pittsburg was the Canadian town of Charterville, Quebec. In this northern section of New Hampshire, the state of Vermont and Maine and the province of Quebec all come together. It was a rather short drive to the Back Lake Camp, and like his other appointments, I remained in the car. After my dad had been gone about fifteen minutes, he came back to the car and told me that the gentleman he was taking the deposition from had invited me to come and sit on his porch and have a view of the lake while Dad finished up the interview. This was fine by me. After Dad completed the deposition, the gentlemen knew from my dad's conversation that he liked to fish, and invited us to join him out on the lake. We found out that he was a New Hampshire fishing and hunting guide but the accident had limited his ability to get around the woods as he once did, but fishing from a boat was no problem. We had a fun filled afternoon fishing and then we were invited for dinner and to stay overnight at the camp. Our new host said to my dad, "I may be suing your company for the accident, but a lawyer who likes to fish can't be a bad guy." We enjoyed a feed of trout and a nice salad.

The camp at Back Lake.

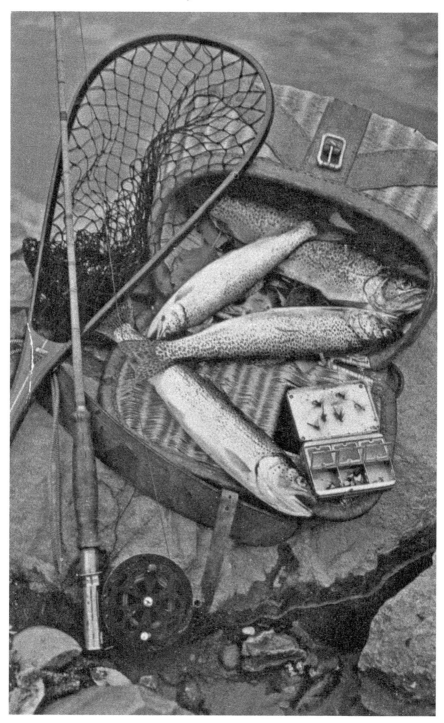

A nice catch.

On Tuesday morning after we had breakfast, we were on the road again, heading for Farmington, Maine. About a half hour on the road, I saw a closed farm stand with a sign that read: "Closed for the duration—gone hunting Japs." It punctuated the involvement of rural American families in World War II. In Farmington, Dad was to see a woman who worked at the state college. It was quite a long ride; we had a picnic lunch along the way and arrived in Farmington by mid-afternoon. We easily found the school's campus and my dad parked the car and walked over to the major building and entered. Since he didn't come out right away, I assumed he found the woman that he was going to interview. I took out a book and read. At about 4:30 p.m., Dad returned, and we were set to move on to our next destination, which turned out to be the Belgrade Inn on Belgrade Lake. We arrived there around 6:00 p.m., checked in for the night, washed up and went to the dining room where we both had a duck dinner.

On Wednesday, Dad had an appointment for a deposition with a man who lived on a farm in China, Maine. After breakfast we took off for this appointment and arrived at the farm around 11:00 a.m. I remained in the car and took out the book that I had been reading while Dad had his appointment. When the deposition finished, my dad and the gentleman he had interviewed came out together and came over to the car. Dad introduced me to the gentleman, who said he wanted to show us a little of his farm and his great view of China Lake. The view was spectacular and I could not believe that he had bought the farm in 1940 for $500.

Our next stop and final deposition scheduled for the trip was in the historic coastal town of Thomaston. It was not quite a two-hour drive from China. My dad's deposition wasn't scheduled until the following morning, so we had a free afternoon. We did check into a large old Federalist home, which was called a guest house; today it would be a B&B. Next we had lunch and then went to the Maine State Prison's store. We ended up buying a few things that the prisoners had made. That night we went to a restaurant in neighboring Rockland for a lobster dinner—it was a great Maine treat.

The next morning, we went to the home of the woman that Dad was interviewing. The deposition took slightly more than an hour. This was Dad's last work appointment for this road trip, so we started south down Route 1. Dad said we should do something special to wrap up our trip and suggested that we stop at Old Orchid Beach for a swim. I thought that would be a perfect way to end our North Country adventure. At Old Orchid we had a feed of fried clams at a clam shack. I had a Coke and Dad had a beer. We then changed into our swim suits and had a dip in the cold Atlantic.

It then was time for us to head home. The trip had shown me the generosity that northern New England folks provided to strangers, as well as how involved everyone was at some level with the war effort.

Donald & Daisy

My dad and my uncles, Bill Harnedy and Arthur Clasby, were all very active members of the Benevolent and Protective Order of Elks. This fraternal organization had a lodge on Kent Street in Brookline. During the fall and winter months, the lodge held monthly dinner dances at the club house to raise money for two specific charitable functions that they sponsored. Each Christmas season, they rented the Brookline Village theater on a Saturday morning in the mid-December time frame and sponsored a movie and Christmas party for all the kids of the town. After the movie, Santa would arrive and hand out a box of hard Christmas candy to each kid. Their second fundraising cause was for a yearly scholarship, which was given to a worthy, college-bound local high school graduate.

To increase the revenue from the dinner dance, the lodge often sold tickets for a drawing that was held on that night. On a Saturday evening, in late October of 1943, the Brookline B.P.O.E Lodge held one of its fall dinner dances. My mother and dad went to this soiree for a fun evening out. As in many of these events, raffle tickets were sold. My parents bought several and the prize that evening was a pair of Peking ducks. You guessed it: when the winning ticket was drawn, my mother was holding it. The ducks were being held in a small wooden crate which was the storage vehicle for taking their prize home in.

Upon arriving at home, Dad put the prize ducks up on the porch, and my mother gave them a dog bowl of water and some bread, as obviously they didn't have any duck food. The next morning, when I learned of their winnings, I was elated. They did not want to have the ducks butchered, so I was to inherit two new friends.

Naturally, I named my two new buddies Donald and Daisy, after Walt Disney's iconic cartoon characters. The next step for our new pets was to prepare a permanent home for them. Luckily, we had in the back yard a large crate that we had kept rabbits in. It was eight feet long and three feet wide with three sides closed in and the front closed with chicken wire fencing, which was great for

most of the year but not New England winters. The crate had two doors in the rear, making it easy to clean. The house provided two barricades, but fencing would be required, so the ducks would have space to get out and play. They also needed both a water and food container as well as special food. These items and work on the project had to wait until Monday, as in that era, stores were not open on Sunday due to the Blue Laws.

On Monday afternoon, my dad came home early from work so that we could go and get the needed supplies for our new pets. As I recall, we drove out to Dedham and picked up six 2 × 4s, a 25-foot roll of 4-foot-high chicken wire fencing, and a small roll of 3-foot-wide tarpaper. My dad said we would need to put this up across the open chicken wire front for the winter to keep the snow out and reduce the cold. After purchasing these items, we went to a grain store and bought a large bag of corn kernels, which the clerk told us was ideal duck food. We also acquired a small galvanized water feeder and food feeder; both of these allowed either the water or the food to keep filling at the proper amount until the feeder was empty. We were pleased to also find out that in the future we could have 25 pounds of the duck food delivered to the house.

I was happy that the first segment of providing more permanent living accommodations for Donald and Daisy had been accomplished. I filled the two new feeders and placed them in their crate. They seemed pleased with the corn kernels. The fencing task would have to wait until the next day.

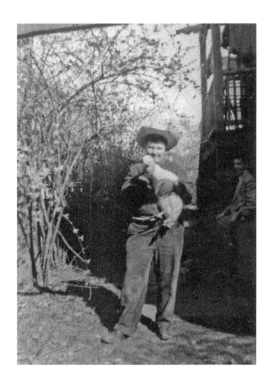

Donald and me.

When I came home from school, my friend, Randy, agreed to help me with making the duck pen. I was delighted that he was going to help, as he was very good at carpentry and I couldn't hammer a nail straight (and still can't). Randy checked out the materials we had purchased for the project and asked what we were going to do about a gate to get into the pen. I told him I didn't have a clue. He said, "Let me go back over to my house and see what scrap materials my dad has in the cellar workshop." In a short time, Randy returned with a 3 × 4 piece of lattice, some other scrap wood, two old hinges and a simple locking device. I told him I couldn't possibly have done this project without him. We then got busy digging trenches for the fence posts. After completing that part of the job it was time to do the carpentry. For those tasks, Randy was the boss and I the goffer. By the time the sun was starting to set, we had their new home completed.

The following day, Donald and Daisy had their full taste of freedom. They seemed to relish being able to run around and play. Late each afternoon when I fed them, I would close them in their crate for the night as a safety measure.

November 11 was Armistice Day (since 1954 re-named Veterans Day) and the day we harvested our last root vegetables from the Victory Garden, with the exception of celery, which left out until near Thanksgiving. We also thought that this was the right time to cover the front section of the ducks crate for the winter with the roll of tarpaper that we had gotten. It was easy to install and was tacked up very quickly.

Winter did come with snow. On the days I knew from the weatherman's radio forecast that we were to get snow, I kept the ducks penned in. After the storm, I would shovel out their play yard and let them out.

Donald and Daisy were very smart and made wonderful pets. My mother and I would often take some bread and throw it down to them from the upstairs bathroom window. My mother would always say "bread from heaven," rather than the popular song, of the time, "Pennies from Heaven."

I kept Donald and Daisy for a little more than two-and-a-half years, but in June of 1946 I knew that I had to part with my friends, as I was going to be starting prep school in the fall and would not have the time to give them the care they deserved. I found a pet store owner in Alston who wanted to have them for his personal pets.

My Daisy Red Ryder Air Rifle

In September of 1943, after returning back to school, I decided that I wanted to make some money for Christmas. At my age there were not many opportunities open, as I was still too young for a paper route, which was the best paying job at the time for a kid. I came up with an idea of offering a shoe shinning service to people in my neighborhood. I thought that it was something that wasn't weather dependent like snow shoveling jobs. It turned out to be a good choice as most of our neighbors were delighted with my new service. I charged 25 cents per pair of shoes and offered delivery 24 hours a day.

My biggest neighborhood customers were the MacKenzies. Mr. Laddie MacKenzie Sr. was a salesman, and his daughter a singer, dancer and actress who entertained in shows and clubs around the Boston area, and also taught acting. They both kept me quite busy and I became very friendly with them. At that time, Laddie MacKenzie Jr. was a Marine pilot fighting in the South Pacific.

The fall of 1943 moved ahead rapidly, as in late October I received two new pets, Donald and Daisy. They kept me busy getting their housing ready for winter. Then came the holiday days and before I knew it winter was upon us. Winter increased my shoe shinning business.

I believe it was in either late January or early February when I made a delivery of shined shoes to the MacKenzie household, that Mr. MacKenzie said, "I have something I'd like to show you." He went to the hall closet and came back out with an Official Red Ryder Air Rifle. He told me that it had been his son's but now that he was over in the Pacific using real guns in the war he didn't need it anymore, and if my parents allowed me to have it, it was mine. I couldn't believe my ears. I had always wanted a Red Ryder carbine. Every comic book featured them and my best friend, Randy, had just gotten one for Christmas.

I didn't have much confidence that my folks would approve of the gift, as my mother especially hated guns, and every time I would bring up the subject she would say, "No, you'll shoot your eye out." Years later, I saw the film *A Christmas Story* and heard Ralphie's fantasy that his teacher Miss Shields was reading from

his Christmas theme, and stated it was theme that she had been waiting for all of her teaching career. She thought that his desire for a Red Ryder BB gun was just perfect and deserved an A+. While I never had a fantasy like Ralphie's, I certainly longed for one, especially after my best friend, Randy, had gotten one, and he was younger than me. Mr. MaKenzie said that he would call my parents and tell them about my gift. I certainly appreciated his offer, rather than my having to deliver the message. Thankfully he called at night and talked with my dad rather than my mother.

A long discussion took place between my parents. Mother was very negative toward the possibility of me having a BB gun, while Dad thought it was not such a terrible thing for a boy to have, as long as he used it with care. The final outcome was that I was allowed to have the air rifle as long as I followed a set of rules that were set down. If I failed to observe the safety rules, no more BB gun. I'm sure I would have agreed to any rules in order to have the prize possession of a Daisy Red Ryder BB gun.

Rogers Daisy Red Ryder Air Rifle advertisements. *Courtesy Rogers Daisy Airgun Museum.*

I couldn't wait to tell Randy of my super new gift. Naturally, he wanted to see it. I told my dad that I'd like to show Randy my new prize. He said fine and told me to have Randy over when he was home, as he wanted to see how I presented my BB gun. On Saturday morning, Randy came over and I presented my Red Ryder BB gun to him in the presence of my dad. He later told me he was proud of how safely I handled the situation, and that he expected me to continue to always be overly cautious when around a firearm, as they were not toys.

As winter moved into spring, I was anxious to use my Red Ryder gun. My dad found out that a safe place for Randy and I to go for target practice was the town dump in South Brookline. I think he knew it was quite a hike and we wouldn't be going there a lot. Over the next few months, we made several fun filled jaunts to the dump for target shooting.

Over time, both Randy's and my interests changed and we moved on to other activities. I don't recall whatever happened to my Red Ryder Air Rifle.

A Visit to Mother's Homestead

My mother, Helen Flanagan Harnedy, was born in Boston, Massachusetts, on July 3, 1892, to James J. Flanagan and Mary Louise Higgins Flanagan. Unfortunately, I never knew either of my maternal grandparents, as they both had died a decade or more before my birth.

Thankfully, my mother kept their legacies alive by telling me of their lives, as well as what her life was like growing up in Boston's South End during the late 19th and early 20th century.

My grandparents were both born in the beautiful but rugged counties of western Ireland. My grandmother, Mary Louise Higgins Flanagan, was born in Roscommon County and came to the United States with her parents as an infant. They settled in the central Massachusetts town of East Brookfield. I suspect that they chose this community as their relatives, the Brennen family, had already settled in the area. My great grandfather was well educated and was fluent in four or five languages. He had hoped to obtain a teaching position in his new community, but being an Irish Catholic, there was no opportunity for him to be hired. Thus, he ended up working in the local mill. Most of his fellow workers were French Canadians that had emigrated there to work in the mill. My mother told me that her grandfather taught many of his fellow workers English at night. She said that he also thought that French was a beautiful language and taught my grandmother the language. My grandmother had a brother and a sister that were both older than her.

The Higgins family lived in a three-family home in East Brookfield. The McGuillicuties, another Irish family, were their neighbors. They had a young son who was close in age to my grandmother and went to the same grammar school with her. This young boy was to become as an adult the legendary baseball player, manager and owner of the Philadelphia Athletics, Connie Mack.

As a young man, my grandmother's brother left for California in the 1880s to seek his fortune. He was never heard from again. The west was pretty wild in those days, so it was not unusual for someone to disappear on their way to

California. Her sister contracted TB and died as a young woman. My mother did not know what happened to her grandparents. She believed that they must have died in East Brookfield in the early 1880s, because my grandmother moved during that period to the Boston area, where she worked as a maid for a wealthy family. It was while living in the Boston area that she met James J. (Jim) Flanagan, whom she married.

My grandfather, James J. (Jim) Flanagan, was born in County Sligo, Ireland, in 1853 and emigrated to the United States as a young man after graduating from a Christian Brothers High School with a classical education. He also had developed a good knowledge of horses, as the west of Ireland was well known worldwide as an area famous for breeding and caring for horses. His educational and horse background coupled with his people skills served him well in the position he obtained at Boston's City Yard. He quickly rose to Foreman of the Yard, responsible for the crews, horses, wagons and equipment that maintained a good portion of the city's infrastructure. This position paid a salary of 25 dollars per week and an apartment with all utilities, including a telephone, as he needed to keep in touch with city officials during storms and other types of emergency problems effecting city life. This was considered an excellent job for an Irish Catholic in the City of Boston at that time, as prejudice was a major factor over the large number of Irish immigrants that the local Bostonians felt were impacting and changing the demographic makeup of their city and the country.

It was during the period of the mid-1840s through the years leading up to and following the Civil War that thousands of Irish Catholics fled Ireland for the United States, Canada and other countries as a result of the potato famine that had swept their country. The British politically and economically controlled Ireland with a philosophy that required minimum interference with the market forces of supply and demand and with an insistence that charity should not interfere with private enterprise. This *laissez-faire* policy resulted in the starvation of hundreds of thousands and mass emigration of all who could find a way of leaving. Boston became a home for many of these new arrivals from Ireland.

Knowing the stories my mother had told me of her parents and her childhood, I was excited about having the opportunity to physically go and check out where she grew up. On a warm spring day, my dad drove us into Boston's South End. The City Yard was located at 650 Albany Street. Dad parked outside the address and told my mother and I to get out and go check out the building. The door to the building was open and as we entered, we met a gentleman who worked there. My mother explained her mission to trace her roots in the City Yard and share them with me, so that I had a better understanding of what life had been like for her and her family in the old homestead.

This gentleman became our host and told us that building was then being used as an office for a city department and that he would be happy to guide us

Above left: My aunts, left to right: May Flanagan and Agnes Flanagan as young girls in the early 1900s. *Above right:* Grandpa James (Jim) Flanagan *c.* 1900. *Below:* Grandma Mary Higgins Flanagan *c.* 1900.

Above: Grandpa Flanagan tending his rooftop garden.

Right: Uncle John Flanagan getting ready to leave to fight in the trenches of France during WWI.

Below: Grandma Flanagan and my mother in 1919.

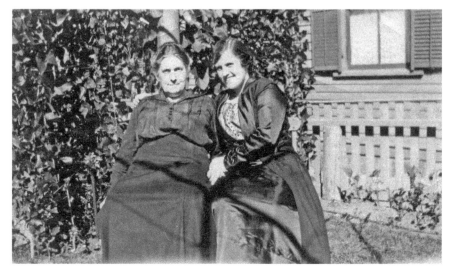

through what was once their apartment area, and answer any questions that he could about how things had changed. He started by explaining that the city had not used horses for years and that much of the work that had been centralized when my grandfather was the yard foreman was now decentralized around the City.

As we walked around what had been the apartment, Mother pointed out what rooms had been bedrooms for her sisters, brother and parents. She next showed me where the kitchen had been and where in their parlor the upright piano was housed that was the heart of their entertainment activities. Mother also told me that their telephone was out in the hall, as the telephone's only use was for grandfather's work. They did not know any friends or family that had a phone. My grandmother had given birth to all of her five children here at home. My mother was the youngest and her sister, Agnes, the oldest. Next born was a son, Joseph, who died as an infant. Mary (May) and John followed.

The return to her childhood roots allowed Mother to recall lots of memories of bygone days, which she joyfully shared with me. She showed me where in the apartment a staircase to the building's roof was and how each summer my grandfather, who loved to garden, had a large flower and vegetable up on the roof. Mother told me how my grandmother loved to cook and entertain and encouraged her children to bring their friends to the house for meals and to enjoy sing-a-longs in the parlor. Mother said her sister, May, had a gift of being able to play music by ear without ever having a piano lesson. Her brother, John, and my mother loved to sing. In addition to lots of singing at home, she was in the choir at their Jesuit parish, the Immaculate Conception Church. Mother knew as a teenager that as an adult she wanted to be a professional singer. Her parent supported her future vocation by having her take private singing lessons.

Mother told me that as a child she loved going into the stable and feeding the horses some carrots and playing with the stable mascot, a huge, friendly St. Bernard. She went to the local public grammar school and to Boston Girls High School. Their neighborhood was what we would call today an urban diverse community, as her neighbors were all working class Irish and Jewish immigrant and African Americans.

Not all of her days at 650 Albany Street were happy ones. Her sister, Agnes, as a teenager went skating and had a fall. When she tried to get up, she couldn't as she had developed some type of paralysis. She was taken to Boston City Hospital where she remained for a significant period, as they were stumped as to the cause. Agnes was eventually sent home with an unresolved problem. She was a very religious young woman who was able to become a Franciscan nun before she died in 1907.

Each summer through my mother's growing years, my grandfather planned a week's vacation for the family in either Maine or New Hampshire. I suspect that as someone who had grown up in rural western Ireland and who as an adult

lived in a city, he loved the opportunity of getting back into a country setting and sharing it with his family.

My mother, her sister, May, and brother, John, remained at home until adulthood. May married a young man from the neighborhood, Patrick Joseph (P. J.) Craffey just prior to the United States entering World War I, and John joined the famous New England Yankee Division at the start of the war. My grandfather died at home in 1918. Unfortunately, John was fighting in the trenches of France at the time and was not able to be home for his father's funeral. My grandfather was buried in Old Calvary Cemetery in the Roslindale Section of Boston.

Shortly after Grandfather's death, my mother and grandmother left the old homestead in the South End and moved to an apartment in Dorchester. Not too long after that, my mother launched her professional singing career in Chicago.

Old Calvary Cemetery in Roslindale is the Boston Catholic Archdiocese oldest cemetery and is an interesting cemetery to visit to gain knowledge of Boston's Catholic Irish immigrants' service as Union soldiers in the Civil War.

Ma Bell Connected Us

New England Telephone & Telegraph was founded in 1878, just two years after its development by Alexander Graham Bell. A year later it was merged with National Bell Telephone Company and one year after that, it merged into American Bell Telephone Company. These mergers were most likely based upon Bell's patent rights. While New England had few early subscribers to this new invention, it certainly was geographically at the center of its development.

My maternal grandfather, James (Jim) Flanagan was foreman of Boston City Yard on Albany Street, and was responsible for the city's maintenance crews, garbage collection and all of the city's horses. As part of his compensation, he and his family were provided with an apartment over the city stable, so that he was available 24/7 to react quickly to blizzards or any other emergency situation that might hit Boston. He also was provided with a telephone, so he could keep in touch with other city departments and the Mayor's Office. My mother told me that the phone was only for City business but it would not have made any difference because none of their friends or family had telephones.

My earliest recollections of a telephone date back to when we lived in an apartment on Dudley Street in Brookline. There, we had a tall standing telephone on a small table in the hallway. I learned that these units were called candlestick phones and were popular during the 1920s. My knowledge and involvement with our telephone at that time in my life was next to zero. When we moved to our home on Sumner Road in 1936, we upgraded our telephone instrument to a black rotary phone. We had a one party line because my dad, being a lawyer, could not have confidential information from clients compromised by someone eavesdropping on their conversation. Most friends and relatives that did have telephone service were on a party line. There were two, three and four party lines. The number of rings identified which party the call was for, but your party line call was potentially subject to being monitored by a nosey neighbor.

New England Bell Telephone & Telegraph had a monopoly control on all telephone service in the area, and was only subject to having its rates approved

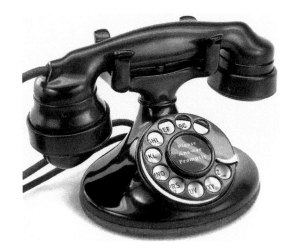

When we moved to our home on Sumner Road, we upgraded our phone to a black rotary type phone with the number: Longwood 3114 (LON-3114).

by the state's utility commission. In those days, there were no area codes; all individual phone lines had an alphanumeric exchange identification. Our number was Longwood 3114 (LON -3114). There were two other exchanges assigned to Brookline, Massachusetts, in the 1930s: Aspinwall and Beacon. My dad's Boston office had a Hubbard exchange. All phone calls outside of one's calling region were long distance calls and had to go through a long distance operator. Long distance calls were charged at a special rate by the minute.

I don't remember our family making many long distance calls. On occasion, my mother's cousin, May Morton, who was a telephone operator in San Francisco would call and talk quite a while to her, as she received free long distance service as a perk for working for Ma Bell's west coast company.

In the late 1940s, we had a long extension cable added to our original 1936 rotary phone, so that at night, it could be brought upstairs to the second floor hallway, making it easier to answer any call that should come in after we had gone to bed. No one in those days ever thought of adding a second phone. I suspect that back then, you were probably charged for the number of phone instruments that you had on a line.

Technology moved slowly during the 1930s and 40s. It was not until the 1950s, when the telephone network had greatly expanded, that a small change came to our alphanumeric addresses. The big change was that our Longwood 3114 address that had been shown for years as LON-3114 was changed to LO6-3114.

Technological changes, coupled with economic, legal and political actions in the early 1980s saw the end to AT&T's monopoly over the telecommunications industry, both nationally and in New England. This ushered in a whole new era.

Cordless phones and mobile cell phones became mainstream during the 1990s. Since then a technological revolution has continued to push ahead and has transformed telecommunications into something once thought about only

through science fiction. The concept of speed dialing or having your area code on your cell phone move with you are but a small part of the changes. Now you are able to watch a movie or a sport's event or take a photo with your cell phone, while sitting at a picnic table, provided that there is a close by antenna to provide you with access to the outside world.

The changes are so profound in the field of telecommunications that they only compare with changing from traveling by horse and buggy to space travel in a period of only several years. While rural America does not have the same communication capabilities as major urban areas, I'm sure that over time this gap will be filled. The telephone land line service that Ma Bell provided to my generation for over a half century is now an antiquated system to be reserved for history.

Winter Saturdays with Dad

My dad loved sporting events of all kinds and started introducing me to a cornucopia of activities that were hosted during the winter months in Boston. My first experience was to go to the Sportsman's Show at Boston's old Mechanic's Building. The Sportsman's Show focused on boating, camping, fishing, log rolling, bird and deer hunting as well as exhibit booths for lots of fishing and hunting camps in New England's three northern states, canoe and kayak booths and booths for power and sail boats. Outfitters from across the Northeast maintained a number of booths and demonstrated various items from archery to dog sleds. By the winter of my tenth year nearly all of the events had moved from Mechanics Building to Boston Garden which was a much nicer venue. The Sportsman Show became the birthplace for both the Boat and RV & Camping Shows, which came on the stage during the late 1940s.

I had always loved farms and farm animals. One Easter, I received a little chick that had been dyed purple. I kept the chick in a box in my playroom, feeding and watering my little friend each day. By early June the baby chick had grown into a good sized hen and needed more room to live a normal chicken's life than my playroom could supply. We called Cousin Tom Brennen, who owned a poultry farm in Oxford, Massachusetts, and asked him if he would be willing to take my pet chicken. Cousin Tom not only agreed to keep my chick but to let her live out a full life on the farm as a pet. We brought her to the farm that June and the good news for me was that I was able to see her whenever we visited our cousins. I learned quite a bit about poultry from my cousin. He raised New Hampshire Red chickens and Holland White turkeys and told me that in New England, both poultry farmers and families with a few backyard chickens normally kept New Hampshire Red, Rhode Island Red or Plymouth Rock breeds of chickens, as they were very hardy breeds and laid brown eggs. New England folks had grown accustomed to brown eggs and thought that white eggs were not fresh, as they had to have been shipped in from the south.

When my dad asked me if I would like to go to the Boston Poultry Show, I was thrilled at the thought of seeing lots of birds displayed. When we arrived

at the show, it looked to me as if Noah had docked his ark full of exotic birds in Boston. The exhibit was arranged with rows of cages filled with chickens, ducks and turkeys of specific breeds. While I could recognize some of the common breeds, I could not believe the great variety of both unusual and beautiful birds. I was particularly intrigued by a breed of chickens called cochins. They came in both standard and bantam size and in various colors. The buff cochin bantams impressed me the most. In talking with one of the exhibitors, I learned that the breed had been developed in China. I enjoyed walking through the rows and seeing all the birds and talking with some of the owners of winning birds. I found out that the Boston Poultry Show had been an annual event since 1848 and that there were more poultry feeds then anyone could imagine. The show was certainly an educational experience for me.

Attending Dog Shows was something that I had been doing, it seems, all of my life. My dad had always bred and showed Wire Fox Terries and we usually had several at home in addition to my Welsh Terrier Brownie, who had been given to me my Mr. Bill Harvey, who owned a terrier kennel in Beverly Farms, Massachusetts. He was also a professional dog handler, who handled my dad's dogs on various show circuits. During the 1930s and 40s, all of the major dog shows were held east of the Mississippi. During the summer months, the shows were held outside, but during the fall and winter, all bench shows were in large indoor venues. In those days the Boston Show was always held in February before the Westminster Show in New York.

When we went to dog shows, our interest was first and foremost on watching the Terrier Breed judging. Having been around terriers for years, my dad had introduced me to a number of the breeders and handlers. While I loved all breeds of dogs, my familiarity with the terriers made them my favorites. After watching the breed judging, we would walk through the bench area checking out all the various dogs being exhibited, as well as looking at a number of booths that exhibited a number of products for dogs. These shows were always exciting for me and fostered a lifetime interest in dogs that culminated in my wife, Jane, and I breeding and showing Kerry Blue Terriers for more than 40 years.

A highlight of many of our winter Saturday trips to exhibits in Boston Garden's was having lunch at Boston's venerable Union Oyster House's Oyster Bar. Here you would sit at the bar and watch your oyster stew being prepared for you. Not only was the service great but the stew was superb. I was told that the Union Oyster House was Boston's oldest restaurant and possibly the oldest restaurant in America.

After one of these great lunches we would take in either a hockey game or a track and field event. I know that we saw the Boston Bruins play several games during those winter Saturdays. In those days the NHL had a much smaller group of teams. At that time there were only the original six teams in the league—the Boston Bruins, the first American team in the league, the New York Rangers,

Boston Garden in the 1930s, where my Dad and I enjoyed many winter Saturday events.

Winter Saturdays were spent with Dad at events at Boston Garden. A memorable one was the opportunity to enjoy a poultry show. I could not believe the number of different breeds of chickens, ducks, geese and turkeys there are. The Bantam Buff Cochin, a native of China, was my favorite of the show. *Courtesy Rogers Daisy Airgun Museum*

Above left: Dad with a litter of his Wire Fox Terrier puppies.

Above right: Dad with one of his Wire Fox Terrier show dogs at Bill Harvey's kennel.

Chicago Blackhawks, Detroit Red Wings, Montreal Canadians and Toronto Maple Leafs. In addition to our seeing professional hockey games on those Saturdays we also watched a number of local high schools play.

Track and Field events were an area near and dear to my dad. As a young man he was a runner and held the indoor mile record for the mile, in a Brookline indoor track, of 4:16 minutes. He later served as a track judge. During the 1940s, both the Knights of Columbus and the Boston Athletic Association sponsored major Track and Field events during the winter season at Boston Garden. Some of the best athletes would come and compete in these events. My dad knew a lot about the fine points of the sport and provided me with a good understanding of the various competitions.

Winter Saturdays with Dad during my growing years were both fun and a learning experience.

Holy Thursday Pilgrimage

I grew up Catholic in an era that proceeded Vatican II by a couple of decades. Up until I was twelve, the Archbishop of Boston was William H. Cardinal O'Connell. He was a very smart but pompous man who enjoyed the trappings of his church position. Today, he would be the very opposite candidate that Pope Francis would select for Bishop or any other high church office, but perhaps, he was a good choice back then to deal with the Boston Brahmins who then ruled the roost.

We were in the Lenten season in April of 1943. It was Friday, April 16, and I had just gotten home from school. I was excited because on Monday we would be celebrating Patriot's Day and I would be on spring vacation. Next week would also start Holy Week with lots of important church functions. I heard a strange noise out on our front lawn. I could not believe my eyes: a strange small ship had just landed there. I rushed out to find a boy about my age getting out of this strange looking machine. I asked him who he was and where he had come from. He told me his name was Sam Blackwell and he lived in Ashburnham, Massachusetts, and his Dad had made him a Time Machine. He had programmed it to take him 72 years into the future, so that he could see what life would be like when he was an old man but he must have hit the wrong button or something. I told him, "Well Sam, you are in Brookline, Massachusetts, not that far from your home, but this is April 16, 1943. You were lucky that you were not shot down as some type of German plane." Neither of us could believe this strange event. I invited Sam to come into the house and meet my mother. My mother was more than surprised by my guest from the future but said that since the next week was Holy Week, God must have given us a special message to share. I was told to show Sam to the guest room and make him familiar with the house. He wanted to know if I had a smart phone or tablet that he could use. I told him I didn't know what he was talking about. He quickly learned that he had leaped way back in time and was in for a very personal history lesson.

After my dad arrived home from work we listened to the news on the radio. Sam could not believe that we received all our news by newspaper and radio and it was so different from the world he had always known.

Being lent and Friday, my mother had made spaghetti with homemade tomato and mushroom sauce. She also made cod fish cakes to go with our dinner. She explained to Sam that during lent we didn't have any sweet deserts.

Sam and I talked, listened to a couple of radio shows and then turned in for the night. On Saturday morning we had a big breakfast. Sam learned that with war being on, most of our food was rationed. We all went shopping at the local A&P after breakfast and Sam learned firsthand how one stood in lines for various products. After we had lunch we all went up to the Friary for confession. Sam could not believe the large number of people lining the rows in front of the confessionals, and how all the women and girls wore hats in church. Within a short time of our arrival there were three priests hearing confessions. We told Sam that on Sunday, we would be going to Mass at St. Mary's. After confession we gave Sam a short ride around town, showing him where I went to school.

Baseball soon became the topic of our discussion. With the season soon opening. I told Sam that I actually liked the Boston Braves better than the Red Sox and hoped that they would win the pennant. I was surprised that he hadn't heard of the Boston Braves. He told me that there was only an Atlantic Braves team. I said that he must be wrong because Atlanta doesn't have a major league team. I went on to tell him what eight teams were in each league. He told me how the leagues now had divisions with numerous teams and that the season had already begun.

We had the standard New England Saturday night dinner, hot dogs, beans and brown bread. We again spent the better part of the evening listening to the radio. I think Sam was enjoying the different pace he was experiencing in the new dimension he had found himself in. Around 9:30 we got ready for bed.

On Sunday morning we all got dressed and ready for church; we would have breakfast after Mass, as one could not eat before receiving communion. Although it was April, it still was a bit chilly, so we put on top coats. Sam could not believe how dressed up we were for church. I told him everyone dressed up for church. When we arrived at St. Mary's, the church was already quite crowded. The organ playing the entry hymn, summoning the congregation to stand as the priest who would be the celebrant of the Mass made his entry with two altar boys. The priest faced the church's large altar to say the Mass, until it was time for him to do the first reading. A member of the choir sang the Psalm and the priest gave the second reading. That Sunday's gospel and sermon were delivered by the pastor, along with the special schedule for Holy Week devotions. Sam was intrigued by the Mass, and he wanted to know what language the Mass was in. He also questioned whether regular people and girls were involved in the Mass. After hearing the Gloria sung, he asked if we ever heard music in English. When the Mass was over and we were in the car, I told him that Mass was always in Latin, and that laity (members of the congregation) did not actively participate on the altar. We followed the Mass in our Missal (the small book I had) and only boys could be altar servers. I'm sure it was a lot for him to digest.

Above: The Mission Church in Roxbury.

Right: The Mission Church in Roxbury.

He asked my dad if we were going to go to the store before heading home, and Dad told him nothing was open on Sunday as there were "blue laws" requiring businesses to stay closed.

After arriving home, my mother made a big breakfast for us to enjoy. We then listened to the Sunday news, which focused on what was happening on the warfront as well as what President Roosevelt was doing. Sam said, "We were studying this in school. I can't believe I'm living it."

Mother told Sam we were going to what was called a Passion Play about Jesus on Sunday afternoon at Mission Church in Roxbury, and he was welcome to come. This was another Lenten tradition that we participated in. After the play, we went home and Mother made waffles for supper and we listed to our regular Sunday night favorites on the radio. Sam told us that he enjoyed his strange journey to the past but needed to get back home on Monday, April 19.

When I woke up, Sam was gone. I told Mother about Sam, and she said I had a fantasy for a dream. She said if there is a Sam somewhere in time, and it was meant for him to find me, he would, but for now we should eat breakfast.

Time went quickly on my vacation week and it was soon Holy Thursday, and the day we were to visit seven churches. Holy Thursday is the day of the last supper, a time that we remember Jesus Christ's last meal with his Apostles on the night that he was arrested. In memory of this major Christian event, after Mass on this day the Blessed Sacrament is placed on the altar of repose and churches are open for silent adoration. When Dad came home from work, we headed out. Our standard route was to visit the Friary, St. Lawrence Church, Infant Jesus Church, St. Aiden's and St. Mary's in Brookline, then on to the Mission Church in Roxbury, and finally the Immaculate Conception Church in the South End completed our pilgrimage.

It was not until Pope John XXIII opened Vatican II in October 1962 did change come to my church. Substance, in this case church teachings, have remained the same. Attending Mass today is very different than back in the pre-Vatican II days. Some churches have Masses with guitar and folk music playing *Kumbaya* rather than liturgical music.

Yes, I caught up with my dream fantasy and know the real Sam Blackwell, his dad and grandmother.

Spring Holidays

Some holidays like Christmas, Easter and Passover are based upon matters of deep religious and spiritual traditions, while other secular ones like Independence Day and Thanksgiving are celebrated by all Americans. The three spring holidays that follow are in this latter category.

One of these falls in April, while the other two are in May. The April holiday is Patriots Day and is only celebrated by the citizens of Massachusetts and Maine. Patriots Day commemorates the first military encounter of the Revolutionary War on April 19, 1775, at Lexington and Concord by the Americans and British. The heroic "Midnight Ride" by Paul Revere to warn the Americans that the British were coming was made part of our culture by Longfellow's poem that has been learned by every kid in grammar school. An equally courageous patriot was William Dawes who also rode to warn the folks in Lexington and Concord of the British plans. His feats weren't captured in prose or poetry of the time, so he became a rather obscure figure in history. Having grown up in Brookline, I was familiar with his heroism, as on April 19 of each year a reenactment of his historic ride was undertaken. Starting when I was around six, my dad, who was a history buff, took me to Brookline Village to see a William Dawes enactor ride through the town on his way to meet Revere. He made one stop in Brookline at the Edward Devotion House in Coolidge Corner before heading on to Cambridge, Lexington and Concord.

Watching the Boston Marathon was where we spent every Patriots Day afternoon. At about 1:00 p.m. we headed from our house to the corner of Tappan Street and Beacon to view the runners as they passed by that spot, which was about a two miles from the finish line in Boston. My dad told me that the Boston Marathon had been originally called the American Marathon when it had been first organized by the Boston Athletic Association in the late 19th century. He also told me that it had started in Ashland but was moved a short distance into Hopkinton in the 1920s.

During the 1940s, there were around 150 runners participating each year. All were men as women were not allowed in the race. Three runners stand out as

being the major force each year: Ellison M. "Tarzan" Brown, an American Indian from Rhode Island, Gerard Cote from Quebec, Canada, and John A. Kelley, a postman from Arlington, Massachusetts. These three seemed to yearly exchange the winning laurel. We always waited to see Clarence DeMar, a marathon winner in years before my time, pass by on his way to the finish line. He always received a big hand from those of us watching this former great.

Time changes many things and in 1996, Patriots Day date was changed from April 19 to the third Monday of each April. Expansion and diversity of the participants has enabled women, handicapped and athletes from around the world to be involved. Today, upwards of 30,000 athletes are involved. Unfortunately, this annual fun event experienced a tragedy on April 15, 2013, when Tamerlan Tsarnaev and his younger brother, Dzhokhar, ethnic Chechen Islamic terrorists, planted two homemade pressure cooker bombs at the Boston finish line and killed three and injured 264. Thankfully, "Boston Strong" became the voice for hope and brighter days ahead.

The first holiday of May was Mother's Day, which was celebrated on the second Sunday of the month. At our house, there was a standard ritual that was followed each year. Starting on Saturday afternoon, my dad would go to the Station Flower Shop and pick up three carnations— two pink or red and one white. Dad explained that carnations were chosen by Anna Jarvis, who was known as the mother of Mother's Day, the symbol for the holiday, as it had been her mother's favorite flower. Either a red or a pink carnation was to be worn to honor a living mother and a white one to

Johnny Kelley, an Arlington mailman, was always a top Boston Marathon contender during the 1940s. In this photo, we see him as the winner.

honor a deceased mother. My mother's mother was dead, so she was given a white carnation; while Dad and I were to don a red or pink one. Sunday morning started out by wishing mother a happy Mother's Day. Next, we went to 9:30 Mass at the Friary. Naturally, we all wore our carnations as did most of the worshippers. After Mass we drove over to Coolidge Corner and had breakfast at a cafeteria-style restaurant. After breakfast we went to Grandma's house to wish her a happy Mother's Day.

We always had Mother's Day dinner at a restaurant. Over the years we went either to the Blacksmith Shop Restaurant or the Red Coach Grill. After having our dinner, Dad would take us for a drive out in the country.

I learned later in life that Mother's Day was a relatively recent holiday addition to our culture. It all started in 1908, when Anna Jarvis wanted to honor her mother, Mrs. Anna Marie Reeves Jarvis. She had been an activist and social worker who had hoped that someday a special day would be established to honor all mothers, both dead and alive. Her daughter, Anna, began the process by having carnations sent to their church in Grafton, West Virginia, for a memorial service for her mother. Ms. Jarvis then campaigned for our country to set aside a day to honor mothers, and by 1911, a number of states had authorized a holiday. On May 8 of 1914, President Woodrow Wilson signed a joint resolution making Mother's Day a national holiday.

John A. Logan, a lawyer, politician and soldier who rose to the rank of Major General and was a Civil War hero, became most known for his work as Commander in Chief of the Grand Army of the Republic, a Civil War Veterans Organization. In that role he established Decoration Day on May 30, 1868, as a day to place flowers on the graves of deceased Union war veterans. In the South, a different day was observed to honor Confederate veterans. By the early 20th Century, May 30 had become nationally accepted as Memorial Day.

Over the years, Memorial Day has evolved to honor all of our deceased veterans as well as a time when Americans go to cemeteries to decorate the graves of deceased family members and close friends. In the spring of 1943, my dad, who was an active member of the Brookline Lodge of Elks, was that year an officer of the lodge with responsibility to decorate the graves of deceased members with American flags. Dad thought it would be educational for me to accompany him to the various cemeteries. After placing flags on the appropriate graves, Dad would point out graves of Revolutionary War dead and veterans of the Civil War, Spanish-American War and World War I. At Old Calvary Cemetery in Roslindale, he showed me a number of graves of young Irishmen who had died in the Civil War. I learned that many of these young men had been hired by wealthy Bostonians to serve in their place in the war, which was a piece of history that I had never heard in school or saw in my history book. I also learned a lot about what the solemnity of Memorial Day meant to America from this experience.

After May 30, 1971, the date for Memorial Day was changed to the last Monday of May, creating a three-day weekend. Since then, the holiday has evolved into a celebration of the start of summer, with cookouts and sports events.

Introduction to
Big League Baseball

It was the early summer of 1944 and I had yet to go to my first major league baseball game. Although the country had been at war since the Japanese attack on Pearl Harbor back on December 7, 1941, baseball continued to be America's national pastime, and major league baseball had not been suspended as the result of a letter written in January 1942 by President Roosevelt to Baseball Commissioner Kenesaw Mountain Landis. The letter, referred to as the "Green Light Letter," recommended to the commissioner that Americans on the home front needed to have baseball played to help them through the dark days of World War II.

During the wartime era, the Major Leagues consisted of eight teams in both the American and National leagues. Boston had two teams, the Red Sox and the Boston Braves. My uncle, John Flanagan (my mother's brother), was a true expert on the national pastime, so I was thrilled when he called to invite me to go and see a Boston Braves-New York Giants game. Uncle John was a mailman and on occasion had a day off in the middle of the week. His schedule was fine for me and my mother asked him to have Aunt Mary and my cousin, Mary, come and have lunch and spend the afternoon with her, while we went to the game.

The eight National League teams in 1944 were the Boston Braves, New York Giants, Brooklyn Dodgers, Philadelphia Phillies, Pittsburg Pirates, Chicago Cubs, Cincinnati Reds and St. Louis Cardinals. Many of baseball's great players like Ted Williams of the Red Sox were in the service. The quality of the game might not have been as good as before the war but I thought it was just fantastic, as I had nothing to compare it against.

The American League also had eight teams back then. They were the Boston Red Sox, New York Yankees, Philadelphia Athletics, Washington Senators, Chicago White Sox, Detroit Tigers, Cleveland Indians and St. Louis Browns. I listened to both the Red Sox and Braves home games on the radio, so I knew who most of the players were on both Boston teams. I also knew some of the stars of other big league teams from a board game, All Star Baseball, which I enjoyed playing with friends.

Above left: Home of the National League Boston Braves in the 1940s.

Above right: Tommy Holmes, slugging right fielder of the Boston Braves.

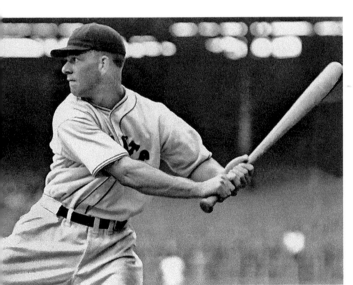

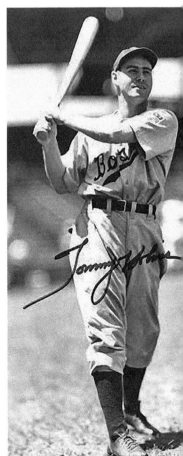

Above left: Mel Ott, New York Giant's player and manager.
Tommy Holmes, right fielder for the 1948 National League
pennant winning Boston Braves.

Major league baseball did not play night games, as we needed to keep lights off at night in case of an enemy attack. The long western road trip for a Boston team of that era was to take the train to Chicago for a couple of games and then move on to St. Louis. There also were no black players in the majors, nor in the major league's farm clubs. There were "Negro Teams" in many large cities including New York, Chicago, Detroit, Baltimore and Atlanta. These teams played either independently of a league structure or in loosely organized associations.

I was very excited when Uncle John, Aunt Mary and Cousin Mary arrived. We had a fast lunch and then Uncle John and I set out for Braves Field over on Commonwealth Avenue in Alston. We walked up to Cypress Street where we caught a Kenmore Square bus and then transferred to a Lake Street car, which took us directly to Braves Field.

We crossed Commonwealth Avenue to the Braves Field ticket counter. Uncle John asked for tickets behind first base as he said that it would give us an excellent spot to watch the game. He also bought a program and told me that he would show me how to score a game. Uncle John loved to smoke cigars and would light one up almost like a cigarette chain smoker, which from a health standpoint was a very poor idea, as his lungs were not that good having been gassed in the trenches of France in World War I while serving with the famed New England Yankee Division.

After taking our seats in the first base section, Uncle John began my education in Major League Baseball. Like a professor, Uncle John's tutorial began describing who the various players were that were warning up in the infield. He pointed to the area out by the bleachers and told me it was called the bull pen and was the place where relief pitchers worked out in case they were needed to come and relieve the starting pitcher. Uncle John knew the pitching records of both the Braves and Giant teams as well as batting averages of each of the players. I told my uncle that he knew more about the teams than the sportscasters I heard on the radio.

The announcer at the park came over the loud speaker to provide us with both the Braves and Giant's starting lineups. This was followed by the national anthem and then it was play ball. As I recall, the first hitter for the Giant's hit a long fly ball to left field; I thought it could be a home run but Uncle John said, "Wait and you will see it will be an easy fly out." He then showed me how to score it on our program. As I recall, there were no runs scored by the Giant's and then the Braves came up to bat at the bottom of the first inning. When Braves player Chuck Workman came up to bat, Uncle John told me, that he had been acquired by the Braves the previous year from the minor league team the Nashville Volunteers. He added that earlier in his career, he played for the Cleveland Indians and then with several minor league clubs.

Uncle John continued with his baseball tutorial as the game progressed. When Mel Ott came up to the plate, he told me how Mel was one of the few

player/managers in baseball and that he had come up directly to the Giants from a semi-pro team and had only played for the Giants. He also told me to watch the odd way he batted.

When we all got up for the traditional seventh inning stretch, he told me how that tradition had started. He said President Taft was quite a baseball fan and liked to go to Griffith Stadium to watch the Senator's play. Taft was a very big man and became quite uncomfortable in the small wooded seat he was in, so in what happened to be the seventh inning, he stood up and stretched. When fans around him saw this, they followed suit. Soon the total stadium was standing and stretching. When the President sat back down the game continued. Naturally, this became news throughout the baseball world and the seventh inning stretch tradition was born.

I don't remember the final score of the game but I do think that the Giants won. In spite of the Braves loss, I became a Braves fan and was very upset when the franchise was moved from Boston. Most of my knowledge of the national pastime I owe to my uncle, John.

A Visit to New York City

I was in the 6th grade when our winter vacation came up in February 1944 over Washington's birthday. By coincidence, my dad had a work trip planned at the time, to go to his company's New York City office and review a number of outstanding claims. He asked me if I'd like to go with him on the trip. I jumped at the opportunity, as I had nothing planned for my vacation and going to New York was a big deal for me.

During my school years, Washington's Birthday Holiday was celebrated on February 22, which, always fell during the week of our winter vacation. It was not until the passing of the Uniform Monday Holiday Act in 1971 that George Washington's Holiday was re-named to Presidents Day, to honor all of our Presidents, and celebrated on the third Monday of February. In 1944, George Washington's Birthday fell on a Tuesday, so my dad scheduled us to leave on that day, as he thought that the travelling between Boston and New York would be light and we would have extra time to spend in the city without the constraints of his work schedule.

We left in the morning, taking the Highland Branch from Brookline Hills Station to South Station. At the South Station, Dad bought us tickets to New York's Penn Station with open return tickets to Boston.

Fortunately, a train bound for New York's Penn Station was scheduled to leave shortly after Dad had purchased our tickets, so we only had a few minutes to locate the track and board our train. After boarding, we walked though several cars, as Dad wanted to find a non-smoking coach car. We soon found seats, and started our Knickerbocker adventure.

Our train ride was uneventful. I had the window seat and Dad pointed out a few things as we pushed forward on our journey, but for most of the trip we just talked, and surprisingly, we soon were pulling into Penn Station. After disembarking, Dad put our luggage in the hands of a red cap and told him, that we were staying at the Pennsylvania Hotel, which essentially abutted Penn Station and was across from New York's iconic sports palace, Madison Square Gardens.

Above left: Red Caps working at Pennsylvania Station in New York City. *Above right*: Hotel Pennsylvania in New York City.

We soon checked into this huge hotel and had a bell boy take our luggage and lead us to the elevator and then up to our room. It was still early afternoon and Dad thought that it would be nice, since we had nothing planned, to call and see if his former mother-in-law, Mrs. Kirbyvite, and brother-in-law, Sylvester (Syl), were going to be home and would like company. Dad's first wife died in her late 30s from major heart problems. Through the years, Dad had kept in close touch with both her and his brother-in-laws. Mrs. Kirbyvite was an elderly lady, probably in her early 80s. She was very British but had married a German. She and her husband and their daughter, my dad's first wife, immigrated to the United States in the early 20th century and settled in Newark, New Jersey. Mrs. Kirbyvite's two sons, Sylvester (Syl) and Victor were both born in the United States. Syl was a bachelor and lived with his mother. He was an inventor by occupation, outgoing and very funny. Victor was the older of the two brothers. He was married, had several children, and also lived in suburban New Jersey and was an executive with a large insurance company. I was to have the opportunity to meet him for the first time in a few days. Dad placed a telephone call from our room to their home and Syl answered and said that they would love for us to come for a visit and have dinner with them. Dad said that was great and that we would be there around 5:00 p.m.

Dad had been to their home many times and was very familiar with the train service from Penn Station to their suburban New Jersey station. In actuality, it

was a very short ride. After arriving at the New Jersey Station, Dad told me that it was a short walk to their house. I don't remember the name of the street, but do remember it looked like a typical suburban neighborhood of that era, with lots of two-family and single homes cramped together on small lots. With the war still on, the street lights were shielded to protect neighborhoods from Nazi air raids. We found their home and were ushered into the living room. Due to the war and its restricted travel, we had not seen either of them in a couple of years. Mrs. Kirbyvite gave me a kiss and said she could not believe how tall I had grown. Syl made my dad, his mother, and himself a cocktail and gave me a glass of ginger ale.

Around 6:30 we went to the dining room for dinner. That evening, Syl had prepared the meal. We had a nice dinner as well as good conversation and then it was time for us to leave and head back to New York. We said our good byes and thanked Syl and Mrs. Kirbyvite for the dinner and chance to visit with them.

We traced our steps back to the local station and caught a train to Penn Station. On our return to our hotel room, we got ready for bed, as in the morning Dad had to go to work at his company's New York office.

After getting up, l looked out of our hotel window, and could not believe how small taxies and trucks looked on the street below. I had never had a room in a skyscraper before and it certainly made an impression on me. Next, I got dressed, and Dad and I headed out for his office. He told me that we would be having breakfast at a deli near his company's office. It turned out to be only a short walk to the deli. I was surprised to learn that this was a deli chain, and one of New York City's icon restaurants—a "Horn & Hardart Automat." I never had seen any restaurant like it. A woman sat on a high stool with a small table and cash register in the center of a cafeteria-style facility. I soon found out that her job was to break dollars down into coins for the restaurant's patrons to use in selecting food from their vending machine style operation. We started in on this unusual cafeteria process in an area devoted to juices. When I saw orange juice, I put in a dime, the door opened and I took out my glass of juice. This was a fun eating experience that I had never seen before. I certainly enjoyed this new adventure in breakfast.

Upon completion of our breakfast experience, we went to Dad's New York office. Here he introduced me to various members of the office's claim department. After the introductions were completed, I was ushered into an empty office and given several magazines to read. Dad then started on his work assignment. We joined back up at noon. Dad, the New York Office's Claims Department Manager and I went to a local restaurant for lunch. This restaurant's walls were adorned with photos of New York sports heroes. After lunch, we all returned to the office where Dad worked for another four hours, while I continued reading magazines.

When Dad completed his work day, we walked back to the hotel. Before we went in, we took time to checkout Madison Square Garden. I had only known this famous sports venue through listening to sporting events back home on my

radio. After looking in at the lobby of this famous arena and reading the signs of coming events, we went to our hotel and washed up for dinner.

That evening, Dad took me to a famous Manhattan steak house for dinner. After dinner, we went to Rockefeller Center. Even more specifically, we went to the area there called Radio City. Dad knew that I loved radio and that I had thought of a career as an announcer, so he found that they conducted tours of the studios throughout the day. The tour we went on was very interesting, as they demonstrated how they simulated certain sounds, like frying bacon and wind howling and waves crashing against a house during a major storm. While visiting the radio studio, I had the opportunity to be on TV, which was still in its infancy. I could not believe how hot the lights were when filming. Dad and others on the tour watched on a monitor.

Thursday morning was a repeat performance of Wednesday. We again walked to the Horn & Hardart Automat for breakfast and then went on to Dad's company's office where he again worked on claims and I read magazines. Dad made luncheon arrangements to meet with Victor Kirbyvite. His office building was close by, so we walked over to it. Like many buildings in Manhattan, it was a skyscraper and Victor's office was on one of the high floors. Being an executive with his company, he had a corner office with a sweeping view of the New York skyline. I found Victor to have a very different personality from his brother, Syl. He was far more reserved and not gregarious and outgoing like Syl. We had a nice lunch in his company's cafeteria, and I know that Dad was pleased to be able to connect with him. After lunch, we said our good byes and returned to Dad's office.

At the close of the business day, Dad and I returned to the hotel. That evening we went to a very nice Italian Restaurant and enjoyed a great dinner. After diner, we took a walk around the area before returning to the hotel. One thing I noticed was the weather in New York City in February was much warmer than our Boston weather. On our return to the hotel lobby, Dad pointed out to me that the Café Rouge featured entertainment each night and that Les Brown and his band of renown with a vocalist by the name of Doris Day were currently performing there. Years later, I learned that is where Doris Day with Les Brown and his band, introduced "Sentimental Journey." With World War II winding down in Europe, this song became America's unofficial welcoming home tune for our troops.

On Friday morning, we planned for our return trip home by packing our suitcases, bringing them down with us and checking them into storage units in the lobby. Next, we checked out of the hotel. Again we had breakfast at the Horn & Hardart Automat, before going to Dad's office. He finished his work up in the late morning. We then went back to the hotel and picked up our luggage before going down to Penn Station. After finding when the first train to Boston was leaving, we grabbed a fast lunch in the station, prior to boarding the train.

After boarding, and settling in our seats we prepared for our trek back to Boston. When we arrived back at the South Station, Dad said, "I think we've had enough of trains for one week. We're going to take a cab home to Brookline."

The Passing of FDR

It seemed as though President Roosevelt had been our president my entire life; well almost, as he had been elected on November 8, 1932, several weeks after my birth. He was not inaugurated, however, until March 4, 1933, as the term of a president did not start until then. The 20th Amendment changed the start date of a presidential term to January 20th and became effective for FDR's second term.

The country was at the very height of what became known as the Great Depression in the fall of 1932. After the stock market crash of 1929, the nation's economy spiraled downward and President Hoover did not intervene to bolster the economy, as he did not believe it was a job for the government. Roosevelt was elected by a huge plurality on his positive message of a New Deal.

President Roosevelt implemented his campaign slogan of a New Deal as a historical transformational program to counter the depression and hardship that Americans had been facing.

November 3, 1936, saw FDR win a second term in a landslide. His Republican challenger, Alfred Landon, only was successful in winning the electoral votes of Maine and Vermont. The New Deal programs that had been enacted had proven to be highly popular and helped his victory.

FDR won a third unprecedented term by successfully defeating his Republican rival Wendell Willkie in November of 1940. The dark clouds of war were on the horizon and this enabled FDR to overcome the two-term precedent for president established by George Washington. A little over a year later, the Japanese attacked Pearl Harbor and America was at war.

My dad was a lifelong Democrat who vigorously supported FDR in both 1932 and 1936 campaigns, but when he chose to run for a third term, he could not support him, as he believed that George Washington had firmly established a two-term limit and that should not be broken.

Roosevelt's third term saw the war effort cranking up on the home front and our military involvement in Africa, Italy and in the Pacific. All indications in early 1944 pointed to a new front in Europe. On June 6, 1944, "D" day took place when

our troops hit the beaches of Normandy. That evening, FDR went on the radio and asked his fellow Americans to join in prayer for the success of our soldiers struggling to get a foothold on the beach. Thankfully they were successful.

Approximately six weeks later in Chicago, the Democrats met to nominate FDR for a fourth term. They also nominated as their ticket's running mate a little known conservative senator from Missouri, Harry S. Truman, over the more progressive Vice President Henry A. Wallace. The Democratic candidates ran on the slogan "Victory and a Lasting Peace."

The Republicans also met in Chicago to choose their nominees. They choose Thomas Dewey, governor of New York to be their presidential candidate, and Governor John Brinker of Ohio for vice president.

On November 7, 1944, President Roosevelt and Senator Harry S. Truman won a significant victory at the polls. On January 20, 1945, FDR was inaugurated for a fourth term and Harry S. Truman became the nation's new vice president.

A short few weeks later in February of 1945, FDR met in Yalta, a Black Sea resort, for a conference with British Prime Minister Churchill and Joseph Stalin, prime minister of the Soviet Union. The conference focused on the allies ending the war and on post-war issues. When President Roosevelt returned from this conference both the newspapers and radio commentators noted that the conference had taken a toll on his health.

The Russian resort town of Yalta hosted the World War II Conference in early February 1945 as the war in Europe was beginning to wind down. *From left to right:* British Prime Minister Winston Churchill, President Franklin D. Roosevelt and Soviet Premier Joseph Stalin.

To recuperate from the stress of the conference, he decided to take a two-week vacation in late March to what had become known as the Little White House in Warm Springs, Georgia. He had enjoyed going there for a number of years since he had been stricken with polio. On the morning of April 12 he was sitting in the living room of the cottage with two of his cousins, Lucy Mercer, the woman who he had an extramarital affair with, his dog Fala, and the portrait artist, Elizabeth Shoumatoff, who was working on a portrait of the president. In the early afternoon, he complained of severe pain in the back of his neck and one of the women called a doctor. He soon collapsed and when the doctors came, they pronounced him dead at about 3:30 p.m. of a massive cerebral hemorrhage.

After Mrs. Roosevelt received the news of her husband's death, she made arrangements to fly that night down to Georgia. Vice President Truman was informed of FDR's death and was sworn into office as the nation's 33rd President.

The evening radio news was almost exclusively given to coverage of the president's death. I know we stayed in the living room listening to our radio console, which was providing all kinds of tributes to the late President. All regularly scheduled programs were canceled that night to give exclusive coverage to FDR's death. When I went up to my room, I put on my small radio to listen to more news. What was interesting was that the broadcaster would provide some interesting tidbit of information about the late president's life and

The funeral of President Franklin D. Roosevelt.

then the station would play "Home on the Range"—Roosevelt's favorite song. That particular format continued for as long as I stayed up listening.

The next morning after breakfast I headed off to my junior high classes at Mt. Alvernia Academy in Chestnut Hill. When I arrived at class I found out that we were going to have a special Mass for the president in the school's chapel. Soon after I entered the chapel, my classmate, Charlie Murphy, came in with his dad and great uncle, who I immediately identified as James Michael Curley, the former Boston mayor and governor of Massachusetts. They entered the pew in front of me. Several girls from my class came and filled up the pew. A Jesuit from Boston College, which was directly across Commonwealth Avenue, came over to say the Mass. He provided a few tributes to the president before starting the Mass. After the Mass we all said good morning to the governor and Mr. Murphy before we headed off to class. Needless to say most of the day had some discussion relevant to FDR.

We heard that evening on the news that the funeral was not to be a large state one as too many men were being killed daily in battle, so the funeral would be a short service in the White House. The body would then be taken by train to the Roosevelt estate at Hyde Park, New York, where he would be laid to rest.

The next morning papers showed the train on its way to upstate New York and people lining the tracks to bid their farewell to the president.

The president's internment on the estates grounds consisted of a short Episcopal service by a priest, as he had requested. This ended a major chapter in America's history.

Home Delivery Services

In the years of the Great Depression and World War II, America became used to shopping at their front door.

There were many obvious services—the paperboy would bring both the morning and evening papers. Having delivered Boston papers for several years as a kid, I was personally familiar with this service. Back in those days, Boston had four morning papers and three evening papers plus the *Christian Science Monitor*, which was more of a national paper than a local one. Magazines like the *Saturday Evening Post* were also sold and delivered to the door.

The morning milk delivery was another standard. During the 1930s, my family dealt with Noble Brother's Dairy until they were bought out by Hood's. Deliveries first came by horse and wagon but by the 40s they had given way to trucks. After you had finished your milk from the glass bottle you rinsed it and recycled it back to the milkman. On cold winter mornings the cream would rise out of the top of the bottle.

Bakery goods were another commodity available at one's door. In our neighborhood we were served by two different bakery firms. Monday, Wednesday and Friday the Gentile's Bakery truck came, while on Tuesday, Thursday and Saturday the black and white mini vans of Cushman Bakery came with their tasty treats.

Other home delivery companies that were purveyors of food to our neighborhood were Jewell Tea Company and the venerable S. S. Pierce Company of Boston. Jewell Tea's salesperson made house calls providing information about their product lines which consisted mostly of coffee, tea, jams and jellies, cookies, herbs and an array of kitchen items. S. S. Pierce required that you contact them by phone and talk to one of their sales clerks. He (there were only male clerks then) would both tell you all of that week's sales items and take your order. A few days later the S. S. Pierce deliveryman would bring your order to the door. Over time a strong customer relationship would be formed with all of the folks directly involved in home delivery.

The first milk deliveries that we had
were by horse and wagon.

Like today, heating fuel was delivered when ordered. During that era, coal
and oil were the two major heating products used in our neighborhood. Many
people did not have refrigerators but kept their food products cold in ice chests.
The iceman made regular calls in the neighborhood. If you required ice you
posted a special card in a central window. When the iceman arrived to fill the
order, he would put on his rubber bib, grab his tongs and a piece of ice, weigh
the ice and then deliver it. He also carried kerosene, which many used in their
kitchen stove. During the summer months we kids would get small pieces of ice
off the truck to chew

Washing machines and dryers were not appliances found in most homes of
that timeframe. Many women washed their clothes by hand and hung it out on
clotheslines to dry. In the winter, the clothes on the line would freeze and feel
very hard and stiff when you went to bring them in. This factor led to many
people buying laundry services. The laundry company would come and pick up
your dirty wash and return it within a few days. Cleaning companies would do
the same. They would come and pick up your dress, jacket, suit and other items
requiring cleaning and ironing and return them in a short period of time to your
home. Folks kept their shoes for a long time in those days and when one's shoes
needed a new sole or heel, you would have the local cobbler stop by, pick up the
shoes and return them after he had repaired them.

Mothers with a young baby didn't go to the local grocery or drug store and
grab a package of Pampers off of the shelf because they did not exist then.
Instead, mothers either bought their own diapers for the baby and washed and
dried them or rented them from a diaper service firm that would drop off clean
diapers and pick up the dirty ones each week.

Medical care was a call away. After the call to his office, your family doctor (then known as GP, general practitioner, rather than primary care doctor) would come to your home with his little black bag (usually in the mid-morning after he had done his hospital rounds), check you out and determine what to prescribe. If he believed you needed to be seen by a specialist, he would often arrange for the specialist to come to your home with him. Even though medical insurance did not exist, medical care was affordable. If your pet came down with a health problem, you called your local veterinary and he would stop by to treat the animal.

Other vendors that would arrive at your door were the Fuller Brush man, encyclopedia salesman and every summer, the ring of the Good Humor man would announce his nightly arrival in the neighborhood. The only one not yet represented in home delivery service was the Pizza delivery man.

The Grease Pig Saga

Summers in Brookline for kids were great, as the town provided all kinds of sports equipment as well as board games for us to use. College kids were hired for the summer by the town to supervise activities at each of Brookline's playgrounds. A young woman was in charge of the younger kids (five and seven year olds) and the girls. A young man gave coaching hints to the younger boys and told us older boys which baseball diamond to use and provided us with equipment. The summer playground days were divided into morning and afternoon sessions. One day each summer, everyone was taken to a major league game. The event was called the knothole gang's day at the ball park. Everyone who went on this field trip sat in the bleachers. We also had an opportunity to swim at the tank (the town's indoor pool), which was across the street from the Cypress Street Playground, which I used during the summer period when I was not away on vacation.

On those summer days when we went to the playground in the morning, we usually didn't go back there in the afternoon. On many of those days, if we didn't go swimming in the afternoon, my buddies and I hung out on our front porch and played a board game called "All Star Baseball." Our front porch had three classic wooden rocking chairs with wicker backs (which seemed everyone had in that era) plus a small wooden table which provided all the items and comfort necessary for enjoying a hot afternoon. This particular afternoon, Randy Filmore and Herby Meehan were with me to play our favorite game. We would each take turns being the manager of the American League and National League teams and the winner of the game would then challenge the non-player to take over the losing team. Each team consisted of a number of players on a cardboard disk. The disk had single, double, triple, homerun, walk, strikeout, fly out etc. It was placed in a ring and you spun a dial that would land on a specific game play. The game would last the normal nine innings but could go to extra innings until the tie was broken.

I do not remember who were playing at the moment we heard this wild noise coming from across the street. Seconds later we saw this strange little animal

darting down Summer Road toward the Cypress Street Playground. Randy said we had to catch it. He didn't specify what we were supposed to catch, but off we went on what turned out to be the adventure of the summer for each of us.

As we headed down Summer Road, Windsor MacKenzie and his friend, Tommy Ferguson, joined in the chase. We all were soon halfway across the Cypress Street Playground, crossing through a girls' softball game as well as avoiding the swings at the end of the playground. I now saw that the little animal that was the size of a small dog was a very small pig. I had no idea how a little pig could have been in our neighborhood. The little guy was very fast; he entered Cypress Street at the corner of Davis Avenue but continued down in the middle of Cypress Street with all of us in strong pursuit. I sure hoped that we could head him off and catch him before he reached busy Washington Street. Just before we reached the intersection with Waverly Street, our little pig friend diverted himself into a fenced in yard off Cypress Street. Now the fun began, as we tried to corner him and catch him. We didn't realize that when he had escaped he had gotten himself coated in some kind of oil, making him a true greased pig. Randy, Herby, Windsor and I finally cornered him by some bushes. I had a shot at a football tackle and I grabbed him. I doubted that I could hold him for long; thankfully, both Randy and Herby put their arms around him, so now the challenge was for us all to get up off the ground and not let him go. We didn't know that the Brookline Police had been alerted and had entered the scene. Randy whispered to me, "Don't say that the pig came out of my back yard." The next thing we knew the police officer took charge of the little pig and told Randy, Herby and I to get into the cruiser. Windsor and Tommy said they wanted to take a shower before supper and their night game. Plus, there wasn't enough room in the cruiser for all of us. As we pulled off, the officer said, "You boys certainly had an exciting afternoon. We are going to take the little pig to the Angel Memorial on Longwood Avenue, the same as we would a stray dog." The pig had been placed in a dog crate that the cruiser was equipped with and put on the front seat next to the officer. When we arrived at the Angel Memorial, the officer carried the crate and we followed him into the facility. Inside we were greeted by a surprised couple of the staff members who said it wasn't often that a pig arrived there.

Naturally, we were asked how our adventure with the pig had begun. We said that we heard a strange noise out on Summer Road, while we were playing a game on my porch and then saw this little animal go streaking down the street. Next, we followed in hot pursuit and finally caught up with him in a yard off of Cypress Street. Naturally, at Randy's request, we kept mum about the fact he had come up from Randy's backyard.

The next thing we knew, a reporter from the *Boston Post* had arrived and interviewed us about the event. After we told our story, the police officer drove us home. After we arrived home, Randy told Herby and I that the real story

about the little piglet was that his Uncle Owen Ward had bought him for a family member who had a farm in New Hampshire and was to take him there on the weekend. Prior to his trip north, he was staying for a few days in the cellar of Randy's house. Obviously, he had managed to get out from the pen he had been confined in and in the process knocked over a can of oil during his escape.

The next morning, we were on the front page of the *Boston Post*. Our phone rang off the hook as friends and relatives read the story and called. My dad told me that everyone in his office had read the story and wanted to know more details of what happened.

The saga had a happy ending. Randy's Uncle Owen retrieved the escaped piglet and took him north for a life on a New Hampshire farm.

My First Summer Job

My first entry into the workforce was in the late fall of 1940 when a magazine distributor for *Collier's Weekly* and the *Saturday Evening Post* was sitting in his parked car in front of my house. When I returned home from school, he asked me if I'd like a job. He then got out of his car and explained that the work entailed calling on neighbors and asking if they would like a copy of that week's *Collier's or Saturday Evening Post*. I would then give them a copy and collect the cost for the magazine. The following week the distributor would return with that week's issue, collect from me my sales money and copies that did not sell. He would then give me my sales commission, which I think was ten cents per copy. My employment lasted until Christmas morning, when the distributor showed up around 10:30 a.m. My dad was furious at the inappropriateness of someone arriving on Christmas for a weekly work session and told him that I would no longer be involved with the magazines. I must say that dad's language was not very politically correct when dismissing the distributor.

In September 1943, I made my second foray into the world of business as an entrepreneur. At the time, I neither knew the word nor how to spell it. My new venture involved starting a shoe shine service in my neighborhood. This activity turned out very well, as I received an unexpected perk by the gift of an Official Daisy Red Ryder Air Rifle from a customer.

During a part of 1944 and 1945, I had a daily paper route delivering both morning and evening papers as well as the Sunday papers. In those days, there were four morning Boston papers, the *American, Globe, Herald* and *Post*. In the evening, I delivered the *Globe, Record, Traveler* and the *Christian Science Monitor* and *PM*. These latter two were not strictly Boston evening papers but had more of a national appeal. On Sunday, I delivered the *Advertiser, Globe, Herald, Post* and *New York Times*. The papers to be delivered were generally dropped as a tied bundle near the start of my route, but on occasion, I had to go pick them up from Brown Paper Distributing, which was located in the basement of Paine's Store in Brookline Village. I enjoyed doing my paper route but yearned for the opportunity of my first summer job.

Like every kid my age, I loved comic books as well as the ads for Daisy Red Ryder Air Rifle.

Like Ralphie in the classic movie *Christmas Story,* I wanted a Daisy Air Rifle for Christmas.
Courtesy Rogers Daisy Airgun Museum

On June 14, 1946, I graduated from the 8th grade at Mount Alvernia Academy. I was excited about the possibility of finding a real summer job as some of my friends had already landed one. My best friend, Randy, was going to spend the summer working on a farm in New Hampshire; while two other friends were going to caddy at The Country Club in Brookline. Getting one's first summer job for a kid then was a rite of passage that we all looked forward to achieving.

My mother avidly read the *Boston Post* each morning and on a day shortly after my graduation, she spotted a help wanted summer ad for the "Laboratory Kitchen," in downtown Boston. The restaurant was only open for lunch, Monday through Friday, which I thought was perfect. The ad stated further that they were looking to hire several students for the job, and the work hours were from10:30 a.m. to 3:30 p.m. The ad also gave a telephone number to call for an interview. I called and set up a time to meet with the owner.

I told my friend, Herby Meehan, about the summer job opportunity, and my mother called my Aunt Mary Flanagan to tell her about the ad she had seen, as she knew that my cousin, Mary, was looking for summer employment.

On the day of my interview, I wanted to look like a serious candidate, so I dressed in the suit that I had worn for graduation along with a white shirt and tie. To reach the Laboratory Kitchen for my interview I took the Highland Branch train to the South Station. It was just a short walk from the Station to the Laboratory Kitchen on Kingston Street. Upon entering the restaurant, I told the woman I met at the front cashier station that I was there for a job interview. She told me the woman sitting at a small table in the rear was the person I was to see. I walked to the rear of the restaurant and introduced myself.

After the introduction, the owner asked if I had ever had any restaurant work experience. I told her no, but I had held some other jobs, which I then listed. The interview obviously went quite well as I was hired and told to report the following Monday morning.

I was glad to hear that both Herby and my cousin, Mary, had also been hired and would be starting on Monday. Herby and I rode the train together and walked up to the Laboratory Kitchen to be initiated into the tasks of our new job. Herb and I received the same assignment; while my cousin, Mary, and several other girls were selected to work on the hot table, where they would dish out food that was ordered.

The interior upstairs of the restaurant consisted of four circular bars. Restaurant patrons sat on stools around the counter of the respective bars. There was one waitress per bar. They would take orders from their customers and yell them down to the person below who would go to the hot table area and get the order filled by one of the people working there. I would then take the order back and put it on the small elevator and manually hoist it up to the bar area. The small manual elevator was called a dumb waiter, but I thought that was actually my job title. The waitresses upstairs were middle aged women who had worked

there for years. The restaurant's clientele were mostly men and women who worked nearby and ate at the restaurant on a regular basis. The summer months added some customers from folks visiting the city.

When the lunch period ended, my second task, dish washing, commenced. A fellow named Earl who had worked there for quite a while was my mentor for this phase of my duties. I scoured all of the pans and crocks by hand; while the dishes, cups, glasses and utensils were machine washed. Upon completion of washing the utensils, the forks knives and spoons were separated and placed in metal boxes and then shipped upstairs via the dumb waiters. Herby and I were finally ready for our last task of the day, which was to take the metal boxes of cleaned utensils and place them on a scale for weighing. The owner used this system, which I thought rather dumb, to see how many utensils had been stolen. I could not figure out how she would know if two spoons were gone. I was excited when Friday payday of my first week came around and I received payment in cash of $13.00.

At South Station, on my way home, I stopped at a flower shop and bought my mother several red roses. The summer passed quickly but by late August I had been able to save enough money to buy a new suit and a pair of slacks to start my freshman year at St. Sebastian's.

In the school years that followed, I had many different summer jobs. As I look back, I think that they provided a wonderful real life lesson not found in the classroom. Specifically, they taught me how to cope with both unpleasant tasks and demanding bosses. One also I learned is that life is not always fair and you have to make the best of the situation you find yourself in. I hope that young people today will have the opportunity of having summer jobs, as it will provide them with many valuable life experiences.

VJ Day Excitement

May 8 of 1945 saw the unconditional surrender of Nazi Germany. The conclusion of the European phase of World War II was greeted with joy by everyone on the home front as well as by our troops that had gone through so much from the Normandy Invasion to finally bringing the conflict in the European Theater to a close. Our U.S. Army Airman played a key role in the defeat of Germany flying thousands of strategic bombing missions from England in B-17s and B-24s. These missions were so dangerous that a crew's tour would be completed after 25 missions. The odds were pretty high against achieving this goal. Fortunately one of the young men from our neighborhood, Ed Ryan, was one of the lucky ones and had returned safely to the U.S. just before Nazi Germany's surrender.

Everyone was aware of the daunting task ahead of ending the war in the Pacific Theater with an invasion of Japan. The American public had no idea of what an atomic bomb was or that we had a secret group of scientists and engineers working on this super weapon on what the government latter told us was the Manhattan Project. On August 6, 1945, our U.S. Army Air Force dropped the first atomic bomb (called Little Boy) on the city of Hiroshima. The Boston Newspapers and both local and national radio broadcasters provided us with an introduction to the power of this new super weapon and explained that in July an atomic bomb had been successfully tested in New Mexico and how the B-29 Superfortress bomber that delivered the A-bomb had to be specially equipped for this mission. Following this bombing, President Harry S. Truman called for Japan to surrender, warning them of further terror from the sky that would provide utter destruction to their country. The Japanese government completely ignored our president's ultimatum and on August 9, our second atomic bomb was dropped on the city of Nagasaki. The second bomb was of a different design from the first; it was a plutonium implosion device, while the first was a uranium type of bomb. The damage that resulted from these bombings were unfathomable by our knowledge of warfare, according to the news that we were receiving. On

Tuesday, August 14, the first news of a Japanese surrender was heard, and on August 15, it became clear that World War II had ended.

August 15 was the day we had scheduled to go on vacation. My folks had rented a camp on Large Diamond Pond in Colebrook, New Hampshire, from August 15 to Friday, August 31. This would be my second trip to this pond in northern New Hampshire, as my dad and I had gone there on our North Country trip in 1944. My dad had been back to Groteton, New Hampshire, had stayed several more times at the Eagle Hotel, and had become very good friends with the owners, Emile and Mabel Dupuis. We had invited them down to visit us during the winter and it was then that Dad asked them to find us a rental in August. Like on all vacation trips, we packed as much as possible the day before the trip so that we could get an early start, as it was a long ride.

On August 15, we were able to get an early start on our trip. In those days there was no Route 93 North, only old Route 3, which went through one town and city after another. Thankfully there was little traffic as it was sort of a quasi-holiday as a result of the Japanese surrender.

We arrived in downtown Nashua about 11:00 a.m. and suddenly heard a strange rumbling on the right rear of the car—yes, a flat. The tire wasn't too good to start with, as we had to use re-capped tires all during the war years. No garage was open, so my dad changed the tire and said, "We had better return home and see what we can do about a tire tomorrow." I wasn't very happy about the situation but there wasn't much else that could be done. We arrived home and unpacked only the food that needed refrigeration. Next, my dad called Mr. Steve

The Dupuis's camp and boathouse on Diamond Pond.

Above left: Dad at Diamond Pond in August 1945 after VJ Day.

Above right: The camp we rented at Diamond Pond in August 1945.

Dad and I with Jiggs on the boat ramp in front of the camp.

Out on Diamond Pond.

Our August 1945 vacation camp on Diamond Pond.

Ryan, who owned a tire and battery business across from Fenway Park. He told my dad to come in for tire help the next morning, and since the war was over not to worry about the stamps that were used during the war.

As it turned out, there was to be a big celebration down on the Cypress Playground that night. My best friend, Randy, and I had a fantastic time at the celebration and I was actually glad we had the flat tire, as it resulted in a wonderful experience that I would have missed.

The next morning we went to Mr. Ryan's garage and service center and my dad had two new tires put on the car. We found out that Mr. Ryan's son, Ed, had risen to the rank of captain in the Army Air Force and was now involved in a training assignment here at home, and after his discharge planned to return to college to get his degree.

We obviously got off to a late start on our trip north. We finally arrived at the Eagle Hotel at suppertime. We stayed there overnight and didn't get up to the camp until Friday, August 17. Mabel had gotten in touch with the folks who owned the camp and told them what had happened and they said no one was coming in to rent over the Labor Day weekend, so we could stay until then. We actually stayed until Sunday, because Dad thought that there would be a lot more traffic on the road on Labor Day.

Our vacation at the camp was filled with lots of fun fishing, hiking and swimming as well as just enjoying the beauty of the pristine setting.

The best part of the late summer of 1945 was that the four years of World War II were now over and a period of tranquility and peace had arrived.

Christmas 1945

In September of 1945, I returned to the eighth grade at Mount Alvernia Academy. Everyone at school was elated by the ending of World War II as nearly all my classmates had someone serving in the armed services and now they would be coming home.

September's jubilation on the home front remained through the fall. I had my first birthday party in years for my thirteenth birthday. Spirits were super high as we moved toward the holiday season, as folks were certainly more than ready to celebrate. November 11, Armistice Day (now Veterans Day), was especially welcomed. Like in prior years, we used the day to harvest the last of the root vegetables and to clean up our Victory Garden for winter.

This Thanksgiving celebration was different for our family. We always hosted Thanksgiving for the Harnedy clan but this year Grandma's health had deteriorated to a point that it was too difficult for her to leave her house. Thus, for the first time in my lifetime Thanksgiving would be just for my mother, dad and me. We did go over and visit Grandma, Aunt Margret, Uncle Billy, my cousin Bill Raulinaitis Jr., who was home from college, and my cousin, Peggy Ann, and Uncle Bill. Harnedy. We heard the good news that Cousin Mary (Raulinaitis) Hamilton's husband, John, who had been wounded in the Battle of the Bulge, was recuperating well and would be home for Christmas.

The war years saw us add to our pet family. I had lost my wonderful Welsh Terrier, Brownie. We now had an Airedale named Jiggs who was also a great dog. Donald and Daisy, my two ducks, always provided us with a lot of enjoyable fun. During the closing year of the war our neighborhood had a problem with rats due to a shortage of people cleaning the Highland Branch Railroad Line tracks that ran behind the houses across the street from us. As a result, it allowed for these rodents to become a nuisance. My mother suggested that we might think about getting a cat. I thought that was a great idea and in the late summer of 1944, I went to the Angel Memorial and acquired the largest cat I had ever seen for $1.00. He was huge orange tiger, with a red collar that had his name, Snooks,

carved on it. I also received a cardboard carrying case to take him home in. After leaving Angel Memorial with Snooks, I walked up to the corner of Longwood and Brookline Avenue where I was able to catch the bus that took me to Cypress Street. From there, I carried Snooks safely home. After getting home, it was time for Jiggs and Snooks to meet. Jiggs hated cats and as we found out quickly, the feeling was mutual. After a brief skirmish in the kitchen, a Mexican standoff commenced, which would last for as long as we had them.

On the Saturday following Thanksgiving, my mother had me help her get all of our Christmas decorations out from the attic where they had been packed away. I had forgotten some of them as it had been so long since we had used them. My mother was thrilled that the wooden manger, Mary, Joseph, baby Jesus and his little crib, together with the three Wise Men, shepherds and animals had all come through there long banishment without a scratch. The manger had been the center piece of our hallway window display. This year it would be returning to its place of honor. We received a surprise telephone call on Sunday from Mabel Dupuis telling us that Cleo had found a perfect balsam Christmas tree while deer hunting, had gone back and cut it down for us and that it would be arriving by railroad express sometime during the coming week. .

For four years, even Christmas candles in the windows had been replaced with flags showing a member of that household was off serving our country, and in some cases these flags bore a gold star signifying that their loved one had been killed. This year the season would be far more joyous. Lighted candles could return to the windows, Christmas trees could have lights as well as ornaments and tinsel. Families were preparing for homecomings and a wonderful feeling was in the air. By the week following Thanksgiving, we had completed all of our decorations except for the tree.

We had not had a Christmas tree since the Christmas of 1942. Since lights were prohibited due the threat of night air raids, we thought it best to skip having one for the duration of the war. We did have a Christmas wreath on our front door, but that was the extent of our Christmas decorating.

After our tree arrived from the North Country, I helped my dad bring it in the house and put the stand on it. We then raised it and placed it in front of the window on the back wall of the living rom. Next, it was time to start the decorating process. I knew where the boxes of lights and decorations were and went up and retrieved them from the hall outside of the attic. We first tested the strands of lights and were surprised to find that they all still lit after non-use for years. We then all worked together to string them. When we completed the stringing we put them on and were pleased at how wonderful the tree looked. We took a short break to enjoy what we had accomplished before getting back to decorating. We were only seated for a few minutes when our friend Snooks entered the scene; when he saw the tree he couldn't believe his eyes. The next thing we knew, Snooks had climbed up the tree, causing it to crash to the ground.

Dad was furious with what Snooks had done but my mother said it was better he made the mess before we had all the balls on the tree. I remember saying, "You know how he loves climbing trees, I'm sure he thought we gave him a special Christmas present." After resurrecting the tree and again checking the lights, we found the damage to be minor. We again took a break and had a good laugh. Snooks' tree climbing escapade became a standard Christmas story for years.

We did complete decorating the tree. The total holiday season of 1945 was a wonderful time that was enjoyed with family and friends.

A New Beginning

During the school year 1945–1946, I was in the eighth grade at Mt. Alvernia Academy, in Newton, Massachusetts. The school was co-ed through the eighth grade, but was only for girls at the high school level. I was wondering where I would go to high school. My mother thought that I should attend Boston College High, while my dad was not real committal. My friends at Mt. Alvernia were in the process of choosing, but in most cases the choice also depended on taking an entrance exam and passing it to get acceptance to the private schools they hoped to attend. The choices of my friends ranged from Boston College High, Cranwell Preparatory School in Lenox, Massachusetts, River's Country Day School in Brookline, Roxbury Latin located in West Roxbury and St. Sebastian's Country Day School in Newton, Massachusetts. All of these schools were college preparatory schools for boys. The newest of these schools was St. Sebastian's. Its first class opened in September 1941, in facilities that had previously housed The Country Day School, a private boy's college preparatory school that had been established in 1907 by Mr. Shirley K. Kerns. I liked the fact that this school was small in size, new, and that one of my classmate's, Paul Gibbons, wanted to go there, as his older brother, Bill, went there and was active in sports and loved the school. My parents heard my thoughts about St. Sebastian's and started checking the school out. My dad soon found that one of his attorney associates, Harold Field, had a son going there and that it was a great school academically. My mother found that the school was located on the former grounds of The Country Day School where her nephew, Edward Craffey, then in Tufts Medical School, had done his college preparatory work. She also found that St. Sebastian's Country Day School had adopted the educational ideals that Mr. Kerns had expressed and incorporated them into a Catholic tradition for St. Sebastian's.

In March of 1946 on a Saturday morning, I had my introduction to St. Sebastian's with a meeting with the school's headmaster, Father Charles D. McInnis. As I sat in his office on the second floor of the school, he told me that if I was accepted into the freshman class that the curriculum was rigorous

Above: St. Sebastian's School building that houses its classrooms, administrative offices, and some of the faculty's rooms.

Below: St. Sebastian's School as the academic year starts in early September.

and that I should be prepared to spend a minimum of three hours per night on homework, and if I didn't intend to do that I shouldn't waste my father's money or the teachers' time. He also said that if I was serious I would gain a great education as a young Catholic gentleman. After our meeting, he escorted my dad and me around the school and up to what was then called the cage, an indoor athletic facility where both baseball and football practice sessions were held. I guess I was totally overwhelmed by this experience, but came away feeling it was where I wanted to go to school. In April, I took the entrance exam and thankfully passed.

All ten boys in my class heard during late April and early May where we would be starting our freshman high school year in September. My friend, Ronnie Welch, was going to BC High, Charley Murphy was going off to Cranwell Prep in Lenox, while Gerry Fay, Paul Gibbons, and I were all heading to St. Sebastian's. I knew that a couple of my other classmates were accepted to Roxbury Latin. In early June my class prepared for our graduation, and on June 14, 1946, we received our diplomas from Archbishop Richard Cushing at an outside ceremony on Mt. Alvernia Academy grounds.

After the graduation ceremony, our whole class was invited to a party at Paul Gibbons' home. It was a fun event and it officially marked the end of our grammar school educational journey, as we were all going to start off on a new scholastic direction in the fall.

The Wednesday after Labor Day I started my new academic life at St. Sebastian's. It was truly a new beginning, from the logistics of getting to the school via bus from Washington Street, Brookline, to Market Street, Brighton, with a transfer to the Watertown Street Carline and then a short trip on this car to a stop, just past Oak Square. Next came a trek up the hill about a half mile to the school's Nonantum Hill campus. The campus consisted of three buildings: the school building itself, which had classrooms on the first floor, the Chapel and administrative office. The second floor housed the offices and living quarters of the headmaster and two faculty members: Fathers Flanigan and Keating as well as the Science Lab, which also doubled as the "Jug," where students were sent by a teacher for a period of one hour detention, at the end of a school day for having fooled around in class. The Refectory was a one-story building adjacent to the school building where we had a substantial meal at individual dining tables each school day and where academic and athletic announcements were made. The third facility was the Cage. The lower floor housed lockers and showers to support St. Sebastian's athletic programs and upstairs was the Cage, where both baseball and football practice could be held as well as basketball games. Several squash courts were also located on the second floor. In addition to the three buildings the campus had tennis courts and a sports field to support its varsity and JV baseball and football programs.

On my first day on the Hill (as I learned the campus was affectionately called), I found that the Class of 1950, for which I was now a member, was divided into

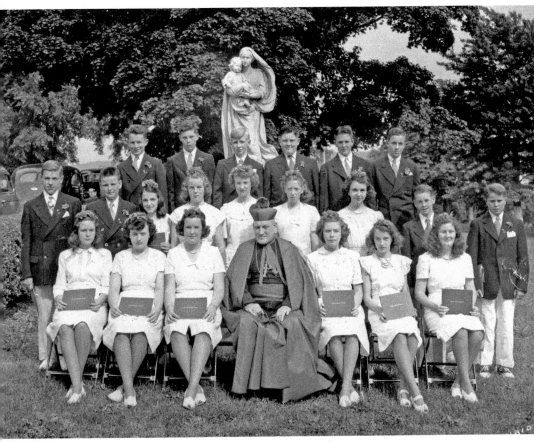

Above: Mt. Alvernia class graduation photo with Archbishop Richard J. Cushing in the center

Below: Headmaster Monsignor McInnis saying Mass in the school chapel for the St. Sebastian's student body.

Left: Graduation day photo of me at Aunty May's and Uncle P. J. Craffey's.

Below: St. Sebastian's School's cage.

Students returning to class from the school's cage after a morning break.

A science lab at St. Sebastian's School.

two sections with approximately 21 students in each. I was assigned to Section A. I also learned that over the summer the pope had raised our Father Charles D. McInnis to the rank of papal chamberlain in recognition of his outstanding service to the church. This honor required us to address him as Monsignor rather than Father. In addition to Paul Gibbons and Gerry Fay, who were my classmates at Mt. Alvernia, I found several other students from Brookline that I knew.

Being in an all boys' school with all priests as teachers was certainly something very new for me. I was aware that the curriculum was going to be difficult and I only hoped that I would be up for it. My class schedule included: General Science and First Year Algebra with Father Joyce, Ancient History with Father Keating, English with Father Beatty and Religion with Father Aubut.

During my first couple of days, I learned what the daily school routine included. Mass was held in the chapel each morning at 8:30 a.m., but student attendance was not required. Classes started at 9:00 and ran until 12:30, when we all, students and faculty, went to the Refectory for a communal meal. Each dining table had seating for six, with two freshmen, two sophomores and two juniors assigned, for a one school reporting period. A priest faculty member sat at each third table and seniors all sat together with Monsignor McInnis. We students served as waiters, with freshmen assigned to serve three days a week,

The St. Sebastian's School faculty.

sophomores twice a week and juniors once a week. Seniors were exempt from serving. After our meal concluded there was a brief period of recreation before returning to class at 1:30. Formal class work ended at 3:00. If you had gotten into any trouble during a class, a teacher could assign you to an hour of Jug. Otherwise you could join any extra curriculum activity that you were interested in or start along home.

Students were encouraged to participate in several school activities over the course of the school year. I went out for freshman football, which was called the JJV team with Father Keating as our coach, and the choir, which Father Keating also conducted.

During these initiation days, I learned that St. Sebastian had not only been a Roman soldier, but he was also a Captain of the Praetorian Guards. As an early Christian, he was persecuted by Emperor Diocletian by being shot by arrows. As a martyr and saint, he is the patron of soldiers and athletes. He was chosen to be the new Country Day School's patron saint by Cardinal O'Connell in 1941. St. Sebastian's martyrdom death is the reason the school athletic team's name is the Arrows. Red and black are the school's colors worn by all of the varsity sports teams.

St. Sebastian's varsity football team opened its 1946 season against Cambridge Latin at Cambridge Latin on Saturday, September 28. My dad and I went to the

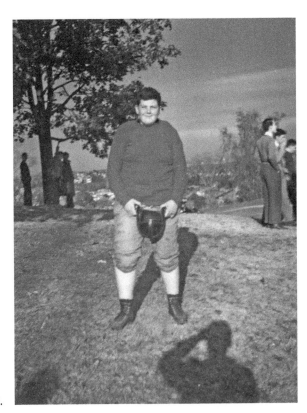

My JJV football initiation
in my freshman year at St.
Sebastian's in the fall of 1946.

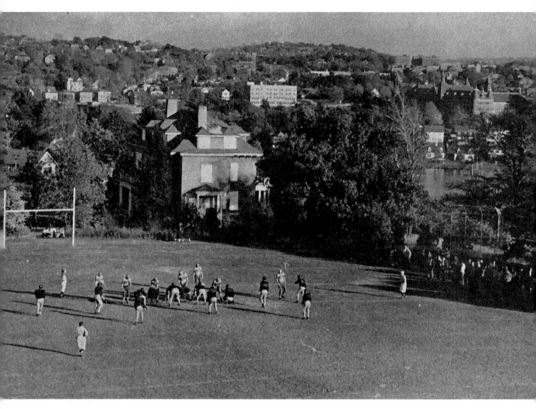

A St. Sebastian's varsity home football game.

game and were thrilled to see the Arrows squeak out a 14 to 13 win over the favored Cambridge Latin.

On the professional sports scene that fall, Boston was overjoyed that its beloved Red Sox had won the American League Championship for the first time since 1918. My dad was lucky and obtained tickets to the first home game at Fenway Park against the St. Louis Cardinals on October 9. I asked to be excused early from class in order to go to the game and was given permission as long as I promised to help the Sox win. Dad and I went and cheered, as Bo Ferris pitched a great 4 to 0 win over the Cardinals.

The rest of the fall of 1946, saw me working hard in class and on the football field both studying and bonding with new friends as well as putting in three to four hours on homework every night. The first marking period came around Thanksgiving. While I set no academic records, I received passing grades in all of my subjects, for which I was very grateful.

Our First TV

On my February vacation of 1944, my dad took me New York City on a business trip. We did do some sightseeing, including a tour of NBC. The tour took us through the radio side of their activities, which at the time was their major operation. On that part of the tour, we learned how various sounds were made for different programs. We then were taken to a studio where they demonstrated the technology of the future. They asked for volunteers to be on TV and I volunteered. I was told to stand up on this small stage that had huge hot lights and camera that I could not see, because the bright lights made me visible to everyone else on the tour. I then saw the next volunteer on the screen. After this brief initiation to the new world of television, I didn't see any TV until the summer of 1946.

Approximately one year after the end of World War II, new products were starting to become available. A small local store on Boylston Street across the street from our A&P grocery store which had been in the business of selling and servicing radios and phonographs had added televisions to their product line. To attract customers, they placed a TV in their store window and one could see the picture on the small round screen of their model. Although you could not hear any dialogue, you could see a picture that was something like a movie and so it became quite a local attraction. On the warm summer nights of August, Randy and I would walk up to get a look at what was on the television. Our interested weaned as we returned back to school.

My Aunt May and Uncle P. J. were the first members of our family to have a television. Shortly after they had gotten it, they invited us over to watch their new TV. We thought their television was wonderful. It physically had replaced their big radio console in the living room. Over the next few months, more friends, neighbors and family members would acquire their first television. Naturally, when one got a TV they invited friends and neighbors over to watch what was on this new technological wonder.

About a week after the Thanksgiving of 1948, a truck pulled up to our door around 5:00 p.m. and dollied in a large box with a GE logo. I opened the door

and invited the fellow with the box on the dolly to wheel it in to our living room. I knew right away that my dad had bought us a television for Christmas. I thanked the man and left the box uncrated. I thought that it was best not to open it until my dad came home from work. My mother wasn't home either, so I was the only one to know of this special gift. I suspected that we would replace our console radio with our new television but I certainly did not know how much electric power it required and if it would actually fit in the same space. It wasn't long before both of my parents were home and we were able to open the crate and inspect our new television. This early Christmas gift was just as a surprise to my mother as it was to me. The next task was to read the GE manual to find out what was required in the way of electric power, how to turn it on and how to get stations that were called channels. The instructions informed us that we had plenty of power where the console radio was and it would fit perfectly in that spot. My mother found a home for our radio a short distance away from its current spot, in the library. My dad and I moved the radio and then we plugged in our new television and saw this marvelous wonder of technology provide a picture.

We learned that Boston's major radio stations had the three television channels serving us. They were: WBZ, Channel 4, The Yankee Network and NBC affiliate; WHDH, Channel 5, ABC affiliate; and WNAC, Channel 7, the CBS affiliate. These new channels were obviously in transition from a radio format to a new and very different media. When the news came on there was no anchor in those days, but an announcer who just read the latest news like he had done for years on radio.

Arch MacDonald was the first TV news person whom I remember on Boston TV. There were not a lot of regularly scheduled shows. Some sports such as roller derby, wrestling and boxing were standard fare in this early era of TV.

During the spring and summer of 1949 we were able to watch both Boston Red Sox and Braves games. The Boston sports announcers were Jim Britt and Bump Hadley, and the sponsor for both the Red Sox and Braves was Narragansett Brewing Company with their familiar slogan, "Hi Neighbor, have a 'Gansett.'"

Boston television in those late 1940 days was not on the air 24/7, rather the channels signed off after the 11:00 p.m. news with the national anthem and resumed airing news the next morning. National news was also in its infancy. John Chancellor was one of the first newscasters. He was followed by John Cameron Swayze. It was several years later before Chet Huntley and David Brinkley made their appearance as nightly anchors.

The golden era of network television arrived in the 1950s with fantastic drama series such as the GE Theater hosted by Ronald Reagan and Playhouse 90, with exceptionally well written dramas by such writers as Rod Serling, Abby Mann and Tad Mosel. The networks staffed their news section with top notch news people both in New York and in bureaus around the country and globe. We thus

received the news we needed to hear, not always what we wanted to hear. News was kept completely separate from entertainment, which is so much different than how it is programmed today.

It was during the mid-1950s that Boston's PBS channel 2 WGBH was launched. This educational non-profit channel has grown over the years to be one of PBS's premier organizations.

We were all used to receiving our television like radio for free. Technology changed this with the arrival of both cable and satellite TV, which no one could have dreamed off in the late 40s. The new technology brought with it a quantity of new channels with 24/7 access now available, even on smart phones. There are now hundreds of channels available, but one has to pay for watching them. Unfortunately, I don't believe that the quality of television today has kept up with the quantity. I suspect that some greed has made its way into the equation and changed this media dramatically.

Grandma's Death

In my Grandma's era, birth and death were viewed as a miraculous transition into a new life. The home served as the portal where life's journey began and where one's death was celebrated and loved ones mourned.

Gradually over time, birthing moved from the home to the hospital. During my growing up years, death was still thought to be the time of a landmark life transition of a loved one who deserved a home-based vigil—a wake was where friends and relatives could express condolences to the immediate family on their loss. It also provided an opportunity to exchange stories about the deceased's life, as well as time to celebrate the joy that the person brought to the world, and a place to speak of the grief that the family members were feeling. The wake launched a normal and understandable mourning process.

Prior to the wake, the family undertaker helped prepare the home for the deceased viewing by placing on the front door a wreath with a purple ribbon to signify that a death had occurred and there would be a wake. Inside the home, the living room and/or parlor, as it was often called, would be the scene for the wake. A table and book for people to leave condolence messages was put in place, a kneeler that was to be placed in front of the casket for deceased Catholics and for some Protestants. The undertaker also arranged in the home some folding chairs for extra seating. Places for floral tributes were planned as well as a tray for accepting Mass cards and condolence cards. Upon completion of these functions, the deceased person would be returned home for the scheduled viewing.

Edwin O'Connor's book *The Last Hurrah* eloquently captures what Boston-area Irish Catholic wakes were like during the 30s and 40s, and adds to the background for understanding the rituals that were associated with death in those years.

The Christmas Season of 1946 saw Grandma's health totally deteriorating. Her doctor told the family that all of her vital system functions had slowed down and that she might not make it through the holidays.

I was fourteen at the time and a freshman at St. Sebastian's. Grandma, my father's mother, was the only grandparent that I had ever known and loved, as all of my other grandparents had died before I was born.

Grandma was 86 years old as she lingered through her last days of life. She had been born in Brookline to James and Anne (McGrath) Donovan on October 20, 1862. Her parents had settled in Brookline in 1860 after emigrating from Nova Scotia. She grew up in the town, was a communicant all her life at St. Mary's Catholic Church and had married her husband, Timothy Harnedy, in 1888. Grandma and my grandfather had seven children. One little girl died as a child; her second oldest, Mary, died in 1917 of influence. Her husband, Timothy, died of pneumonia at 40. In those days, there was no safety net. Thus, Grandma, as single mother, had to immediately go back out to work. Employment opportunities were slim, as low-wage jobs as a housekeeper, maid or cook were all that were available. In later years, she obtained a job with Town of Brookline cleaning restroom facilities. This job paid better and provided her with a small retirement pension when she retired at 75.

During these days over Christmas and New Year's, family members kept a vigil at her bedside. Sometime during this period, a priest from St. Mary's Church came and gave Grandma the church's last rites, which involved blessing her with holy water and anointing her with oils that the bishop had blessed. On New Year's Day, Grandma slipped into a comma. Grandma, the matriarch of the family, lied peacefully in her double bed. Her large bedroom in this old Victorian captured perfectly her life as a 19th century Catholic woman of the Boston area. On the night stand next to her bed was a miniature altar replica of the one in her parish that had been perfectly crafted for her, by Jim Casey, a Brookline police sergeant, who was like an adopted family member. In front of the altar were her rosary beads and a missal (a prayer book used at Mass in pre-Vatican II). Grandma was a small woman physically but she possessed great strength to handle the many difficult challenges she faced during her life's journey. She was never rich but she always had great faith in both her church and in the American dream for her family. She believed that if one worked hard, took advantage of educational opportunities and always treated people fairly, one would succeed in this world. She was very proud of her children and grandchildren and was extremely pleased that three of her children had become college graduates.

On the morning of January 2, we received a phone call that it appeared Grandma soon would be gone. We dressed and raced over to her house. My mother, dad and I, and most of the rest of the family, crowed into the room to be with her as she made her transition to her new life. We all either knelt or stood and prayed for her. After seeing no movement of any kind by Grandma, Aunt Margaret checked her wrist and said, "Mom is gone." There was quite a bit of sobbing and then Uncle Bill said, "I'm going downstairs and calling the doctor to check on mother, and if she is dead to sign a death certificate so that we can contact George Lacey (the undertaker) and St. Mary's." My dad said he would go home and contact Mr. O'Neill at Holy Hood Cemetery and let him know that his mother had just died and she would be buried in a specific grave within the family twelve-grave lot that my Father had bought in 1928.

After getting home, my dad made the call, and returned to Grandma's house with the cemetery deed to give to the undertaker. While we were at our home, the doctor came and determined that Grandma had died, and signed the death certificate so that her body could be released to the undertaker. During that same period, my aunts Helen and Margaret picked out the clothes that Grandma was to be laid out in. The brothers and sisters went together to George Lacey's undertaking parlor to make all the arrangements for the wake and funeral.

By nightfall of January 2, when Dad returned home, all of the arrangements had been made and scheduled. Specifically, there were to be two days of a wake with both afternoon and evening visiting hours with a Requiem Mass to follow at St. Mary's Church at 10:00 a.m. on Monday, January 6. Flowers had been ordered from Alfuso's Station Florists and would be delivered before noon on the 4th to the house, so that the undertaker could appropriately place them before visiting hour started at 2:00 p.m.

Needless to say, that was a very emotionally tiring day for all. After dinner that night we all went to bed early. In the morning we went to Mass at the Friary, came home and had breakfast. My dad gave me a black tie to wear and he told me that I was to be one of the pallbearers along with my cousins, Bill Raulinaitis Jr. and Ed Clasby, uncles Billy Raulinaitis and Arthur Clasby and adopted family member, Jim Casey. The rest of the morning was spent getting ready for the wake. My mother called St. Sebastian's to inform them of my grandmother's death and that I'd be out of school for several days.

We all dressed for the wake, had a light lunch and started down to Grandma's to see her in her casket before visiting hours started at 2:00 p.m. It seemed like right at 2, people began to arrive. The first group of folks were elderly and had been longtime friends of Grandma and the family. There was a lull of visitors between 2:30 and 3:00 but then a large group came to pay their respects. The afternoon visiting hours lasted until 4:00, and the evening hours started at 7:00 and lasted until 9:00. The period between visiting hours gave the family a little time to call folks they had not contacted and have dinner. As I recall that first day of the wake we went to China Village for a fast dinner.

We returned for the second session a little after 6:00, and I remember I had a chance to talk for a short time with my cousin Peggy Ann. She told me the night before was different for her, as her bedroom abutted Grandma's, and it was strange to know she would no longer be there. A few minutes before 7:00 a priest from St. Mary's arrived to say the rosary with the family and visitors. By 7:15 a good number of people had arrived and the priest began the rosary. I was introduced to a number of second cousins, whose names I had never heard of or do I now remember. I think we were all glad when the last person left at about 9:30 and we could go home from an exhausting day.

We awoke for Day 2 of the wake. I was a little surprised that the morning did not seem quite as hectic as the prior few days. Dad had the morning news on the radio and was checking the obituaries for Grandma in both the *Boston Herald* and *Post*. We dressed and went to Sunday Mass at the Friary. Mother made a Sunday-style breakfast and I gave some attention to Jiggs, our loveable Airedale,

and Snooks, our large orange tiger cat, who were both spoiled pets but for the past few days were not given much attention. We finished breakfast a little after 10:30. About 20 minutes later, the doorbell rang and it was Mrs. Ryan, a neighbor, laden with food that she had prepared for the family. A short few minutes later, Mrs. Filmore came to the door with a large bag of food that she had made. Mrs. Ryan and her husband, Steve, had grown up near the Harnedy clan and knew the family their whole lives. Mrs. Filmore was also a townie; she and my Aunt Helen had been friends from high school. We thanked the women for their generous gifts and then started thinking of getting ready for the afternoon viewing. We packed the car with the food and started down to Walnut Street about 1:00.

After leaving the food in Aunt Margret's kitchen and taking off our winter coats, we went into the living room, knelt at the casket and said a few prayers. At 2:00 p.m., people started to arrive. There were lots of Brookline folks, including a large group of both cops and firefighters. The town selectman and members of the school committee, as well as several district court judges, lawyer friends of my dad's and a large group of Elks from the local lodge all came to offer their condolences. There was an overflow crowd from the living room and people were sitting in the dining room and kitchen. At about 3:30, Monsignor McInnis, the headmaster of St. Sebastian's, came to Grandma's wake, I certainly was shocked to see him appear. It became my job to introduce him to all my family. I was very happy when afternoon visiting hour ended.

We went home that night for dinner and to feed Jiggs and Snooks. I was glad that we lived close as it gave us a little time without having to rush through everything. We returned for the evening visitation about 6:30. After we took off our winter coats, Uncle Bill told me that George Lace, the undertaker, wanted to meet with the pallbearers around 8:00 p.m. to go over instructions for the Mass. At a little after 7, a different priest from St. Mary's arrived to say the rosary. In those days, St. Mary's had a pastor and two or three curates. The living room during the rosary was filled and some of the non-Catholics and smokers adjourned to the kitchen. George Lacey gave us our instructions, so we were all set for handling our pallbearer duties. At about 8:30, I needed a break; I saw a light on the back stairway to the basement area, so I went down. Uncle Bill was down there loading up the furnace with coke. Uncle Bill was frugal and heated with coke, which was cheaper than coal. He used the ashes like sand, for traction over snow and ice in the driveway. A few minutes after my arrival, another fellow came down whom I didn't know. He turned out to be a cousin they called "Mattress" Donovan. He came down to ask Uncle Bill if he had a drink for him. Bill was furious by his question; he was the absolute wrong person to ask for a drink, as he had never had a drink in his life. This little episode was the most exciting event of the wake. We left for home about 9:45.

Monday morning, January 6, came and we all got dressed early as Grandma's Requiem Mass was scheduled for 10:00 a.m., and the family had to meet at Grandma's at 9:00 a.m. After a fast breakfast, we left for Walnut Street. The immediate family all wanted to say their last goodbyes, before George Lacey closed the casket. There

Brookline Lodge of Elks officers, left to right: Jim Harnedy, Harold Field, Tom Brady and John King.

St. Mary's of the Assumption Catholic Church in Brookline.

was a strict protocol for the funeral caravan. The hearse would be followed by a vehicle holding the flowers. Next would be the limousine we pallbearers would ride in, followed by several limousines for immediate family members. Seating was in sibling seniority. Thus, my dad, mother, Uncle Bill and Aunt Margaret made up that car. The following limousine carried Uncle George, Aunt Annie and Aunt Helen. The last vehicle carried the remaining grandchildren. We arrived at St. Mary's Church at about 9:45 a.m. to initiate our first pallbearer assignment. George Lacey gave instructions on how to carry Grandma's casket up the flight of stairs into the church. One of George Lacey's associates helped us with this task. Once in the church, the casket was placed on a roller. The Pastor greeted the casket along with my cousin and a grandson, John Harnedy, who was a seminarian and was going to assist the Pastor in the Mass. After the blessing of the casket with both holy water and incense, we wheeled Grandma's casket to the front of the church's altar.

The Requiem Mass was now ready to start. The pastor did the readings and gave a brief homily. Several religious hymns were played (there was no vocal) and then communion, final prayers and a recessional organ piece. We pallbearers would bring the casket out and place it in the hearse. The church would empty first from the front with the immediate family and then each row until the last pews in back were empty.

Our final role would be at the internment at Holy Hood Cemetery. One of the curate's was assigned the internment ritual. He was to ride in the hearse with George Lacey and his associate. My cousin, John Harnedy, was to ride in the vehicle carrying the flowers. The rest of us had the same vehicle accommodations as our ride to the church.

Sergeant Jim Casey had arranged for a police escort of the funeral procession from St. Mary's to Holy Hood Cemetery in Chestnut Hill. The patrol car dropped out as we entered the cemetery. We slowly moved toward the Harnedy grave site. The hearse parked directly in front of the site, and we disembarked the limousine and prepared for our final assignment of placing Grandma's casket in the grave. We carefully took her casket from the hearse, made the short walk to her gravesite and lowered her casket into the grave. The priest, together with my cousin, John, stood next to the grave and prepared to start the internment prayers as soon as all the mourners had gotten to the site. The service was short and we all returned to our vehicles. The next stop was back to 63 Walnut Street.

While we were all at the funeral, friends of Aunt Margaret came to the house and prepared a collation for the family and other mourners to enjoy on their return from the cemetery. After taking off our winter coats, we all gathered in the dining room. We enjoyed the lunch and carried on small talk with a few words about the service. It was then time for us all to move on. A major chapter in the Harnedy family story was now complete. We had all been blessed by the grace and strength of Grandma. Her legacy of love for her family will always dwell in our hearts.

Nonantum Hill Days

Two days after my grandma's funeral on January 8, I returned to academic life at St. Sebastian's. This time, it wasn't a new beginning, as I knew that I was now an Arrow. I enjoyed Father Beatty's announcement: "This is WORK and we're on the air from September to June." He also received our full attention when he would stand on top of his desk each Tuesday morning before our weekly book test and tell us that he wouldn't even trust his mother if she were taking the test. In addition, he would remind us that the book test always had one question about some very abstract character or place mentioned in the book. If you did not answer that question correctly, you failed the test as he would know that you had not read the book.

During the winter of 1947, when having a long wait for a bus home from Market Street in Brighton, I often walked around the corner to my Great Aunt Mary Driscoll's house. She was an older sister of my grandma's and was then in her early 90s. She lived alone, in a small home near the Brighton Police Station. She had four sons, but two were deceased. She was always delighted to see me and would quickly get me some hot cocoa and some cookies or a piece of cake that she had baked. We would talk about the family and how she missed her sister, my grandma. The following fall, Aunt Mary passed away.

St. Sebastian's varsity hockey team lived up to its powerhouse reputation with a banner season under co-captains Bob Murphy and John Slattery. Father Hannigan coached the JV hockey contingent. Freshman major contributors included: Paul Gibbons, Dick Mulhern, Jim Cotter, Jimmy Carroll, John Doherty and Fred Elston. In the hoop world, Father Keating coached the Junior Red and Black quintet. Freshmen on the squad included Bill Carey, Jim Canning, Joe Shea and Dick Shiffman. The JV Arrows had a super season, winning eleven of their thirteen scheduled games. Bill Carey and Dick Shiffman were called up to play varsity ball during the late stages of the season.

The spring of 1947 rolled around and with it came baseball on the Hill. My freshman class produced several varsity players, including Jimmy Cotter and

George McGoldrick, who were both fellow Brookline townies, and Wally MacKinnon.

Before the school year ended, an upper classman's father, Mr. William T. Morrissey Sr., commissioner of the Metropolitan District Commission (MDC), let it be known that his organization had funds for summer jobs mowing lawns, cleaning swimming pools and sweeping roads throughout the greater Boston area, and if any students were interested in a summer job to contact him. My second summer job was working for the MDC, cleaning a pool and a recreational facility near Norumbega Park in Auburndale. It was a great job both for the money and the chance to use the pool off hours. It was easy for me to get to work by taking the train from the Brookline Hills Station to the Auburndale Station The job lasted until mid-August, which was great, as that summer my parents rented a camp on Big Diamond Pond in Colebrook, New Hampshire, for the last two weeks of August. Boating, fishing, hiking and swimming were a wonderful way to close out the summer of 1947.

September 1947 launched my sophomore year at St. Sebastian's. It saw me move up to the JV football squad and start Caesar's Commentaries, under the tutelage of Father Flanigan. Each day, Father Flanigan had us put away our Latin book at the start of class. He would then hand out a soft-bound covered version which just contained Latin text. This was the source we used to provide a translation. After providing a translation, we had to explain some specific grammar or verb usage in the context of the paragraphs we had translated. If we gave a poor answer, we were asked to attend Caesar's tent for a session after school. Caesar's tent sessions commenced at 3:15 p.m. in Father Flanigan's office. During both my sophomore and junior years, I spent a considerable amount of time in Caesar's tent. Sophomore studies also included: Plane Geometry with Father Hannigan, English with Father Beatty, History with Father Keating and first year French and Religion with Father Aubut.

During my sophomore year I was a member of the Mademoiselles Chorus in the school's annual Minstrel Show. We all dressed in female dance costumes and wore makeup and wigs (today, it would be considered going in drag, but those were much different times and with a very different culture). Although not politically correct today, the late 1940s were certainly a simpler time and there certainly was no intentional prejudice being shown. I also joined up with the newly formed swimming team that was organized by Father Harrington. This new entity started out at the Boston University Club pool but migrated to the Tank in Brookline for its formation into a water polo team. The second half of the year saw our class being joined by Gerry Powers, who transferred from Boston Latin. We soon became good friends. One of the benefits of my new friendship was that Gerry's dad, Dr. Powers, drove him to St. Sebastian's and stopped and picked me up on the way. This saved me from traveling by bus and street car for the remainder of the school year. The winter sports scene was a great one, for both the varsity basketball that enjoyed the school's best season ever with thirteen victories

St. Sebastian's students working on a physics project.

A St. Sebastian's School lab scene.

and nine losses, and the varsity hockey squad, which had ten wins with only one loss, again showing what a hockey powerhouse the Arrows had become. Bill Carey from our class was a successful member of the hoop brigade, while Jimmy Cotter and John Doherty were formidable representatives of our class on the ice. The diamond season began with a lot of rookies, as graduation the previous June saw many of the Arrows depart for college. This season was thus a building one, which saw classmates Jimmy Cotter, Wally McKinnon, George McGoldrick and Joe Shea rise to the occasion and provide a major contribution to the team.

Since being introduced to major league baseball by my Uncle John, I had become a devoted Boston Braves fan, and was nicknamed "Tribe" by classmates. When April 1948 rolled around and the major league season was about to begin, my mother received a call from her friend, Mary Ferguson, asking her if she would consider hosting several Boston Braves players for a few days until they found rental homes for their families. My mother immediately agreed to the offer. When I arrived home from school and heard the news I was more than excited and naturally wanted to know which Braves were going to stay with us. A couple of days later we found out that Tommy Holmes, the right fielder, and Phil Masi, the catcher, were the two that would be staying with us. They moved in and stayed with us a week while they hunted for seasonal housing. A second request came in on their departure for a new player with the Braves, Jeff Heath. He had been acquired during the winter from the American league, St. Louis Browns. He was very nice guy; he told us he had a daughter and son and he wanted to find a home to rent for his wife and kids that was fairly close to Braves field, but not too urban, as they were used to rural living in Washington. Being new to Boston, he had no concept of the local communities, so my dad drove around with him to show him some towns he might want to consider looking into. When the season got going, I was thrilled that the Braves were doing fantastic with both great pitching from Johnny Sain and Warren Spahn and great hitting from Bob Elliot, Tommy Holmes and Jeff Heath. During the season, Jeff Heath and his wife and family stopped by to visit us several times.

With the completion of my sophomore year, I requested a summer job again with the Metropolitan District Commission (MDC). Thankfully, I gained an appointment for the summer of 1948. Prior to starting my second summer job with the MDC, Gerry Powers invited Gerry McCourt and me to his family's summer cottage in Gloucester. Mrs. Powers drove us all up to their North Shore cottage and left us to enjoy several great late June days at the beach. Gerry McCourt's mother packed Gerry with enough sandwiches to feed an army. We stuffed ourselves, swam, hiked around the town and had a great time.

My summer job with the MDC was similar to my prior summer work. On weekends my dad started teaching me to drive. I was certainly excited at the thought of getting my license in the fall. Shortly after my job ended in late August, I headed back up to Nonantum Hill for varsity football practice. I was excited about being a part of the varsity squad.

Above and Below: St. Sebastian students and faculty enjoying lunch in the school's refectory.

My junior year on the hill academically involved third year Latin, studying Cicero with Father Flanigan. I anticipated that this would lead to my again spending time in Caesar's tent. Father Sylvester was our third-year English teacher, Father Hannigan taught us second-year algebra and Father Harrington initiated us in the workings of a chemistry lab. Father Aubut helped to increase our knowledge of French and our Catholic religion, and Father Keating provided exciting aspects to History. On the gridiron we opened with a loss to Cambridge Latin. The second game of the season was an away game in New Haven, Connecticut, with Hopkins Country Day School. This was my first experience as a member of the varsity squad to travel and stay overnight for a game.

We left in a convoy of cars for New Haven. I remember that Reed Comperts and Ernie Woeful were two of my car companions for the trip. When we reached Hopkins Country Day School we were teamed up with a Hopkins student, whose family was going to put us up for the night. The Hopkin's student that I was teamed up was a nice kid, and his family treated me like a family member. The following day we played and Hopkins crushed us: 25 to 0. The next game that I remember quite well was in early November against Thayer Academy. It was a cold rainy day and I recovered a fumble that led to the only goal we scored.

When the major league baseball season was ending, my Braves were in first place heading for the World Series. Unfortunately, our friend Jeff Heath had a bad accident in a game against the Dodgers, where he broke his ankle. This put him out of the World Series, which the Braves lost to the Cleveland Indians in six games.

My dad, who had been a lifelong Democrat, broke with President Roosevelt when he ran for an unprecedented third term and did not support him in his 1944 fourth term campaign. With FDR's death, Vice President Harry S. Truman became president, and in 1948 ran for reelection to the presidency. The Republicans nominated Thomas Dewey, New York governor, who had come to fame as New York district attorney, where he prosecuted a number of mobsters, including "Lucky Luciano." One of the attorneys who had worked closely with Dewey had been an associate of my dad's when they were both young T-men investigators together in Washington. This friend asked my dad if he would head up a Committee of Massachusetts Democratic Lawyers for Dewey. My dad agreed and campaigned hard for Dewey's election. The election, in some ways, was similar to the 2016 presidential election in that President Truman was considered a long shot to win by everyone. He ran an unorthodox campaign as an underdog by doing what was called whistle stop campaign speeches from the rear platform of a railroad train as he crossed the country. On Tuesday, November 2, 1948, the nation voted. When we went to bed that night there was not a declared winner. The next morning, in History class, Father Keating brought in a radio so that we could hear the results from California. The Wednesday, November 3, *Chicago Tribune* headline read: "Dewey Defeats Truman." We all sat and listened

Left to right: Governor Thomas Dewey of New York, the 1948 Republican presidential candidate, and Jim Harnedy, chairman of the Democratic Lawyers for Dewey Campaign.

to the news from California, which gave both the popular and electoral votes to Truman, and thus he retained his presidency.

The rest of the fall remained very exciting. The week after Thanksgiving, Dad surprised my mother and me by getting us our first TV, as a Christmas present. Naturally, we were delighted with this gift. A week or ten days later, I took my driver's exam over in Brighton and passed.

We had a nice holiday season which was capped by my having gotten a driving license. This made me feel that I had just fulfilled another rite of passage toward adulthood. My dad let me take the car and see my friends. Locally, Randy Filmore remained my best friend. He was younger than me and could not wait until he could drive. My closest friends from school were: Bill Carey, Jim Delay, Gerry McCourt and Gerry Powers. During the holiday period, I was able to connect for some fun with all of them.

Shortly after returning to class in January, we had award night. I was delighted as I not only won a varsity football letter but was awarded a school jacket. I continued my activity over the winter on the water polo team and was once again in the school's annual Minstrel Show. We also had to develop an exhibit for the Science Fair; I spent quite a bit of time working on my project, which was

hydroponic gardening (growing plants in water without soil). I really enjoyed seeing the project develop.

An interest in dating had begun and for the Junior Prom I asked Ann Riley from Jamaica Plain to go. The prom was held in St. Sebastian's Cage, which was appropriately decorated for the night. After the Prom we went to the Meadows in Framingham for some food and then I took her home. I only saw Ann once after that night.

In May, my cousin Ed Craffey, and his wife, Marion, stopped by to ask my parents if I could accompany Ed on his long drive to Dallas, Texas, in June. Ed had just finished his residency in radiology and had accepted a radiology position in Dallas. Marion planned to join him with their daughter, Ann, after he found an apartment. My folks said that I could go, so for the rest of the school year my thoughts were on a Texas adventure.

Texas Adventure

My mother had some reservations about me accompanying Ed to Texas because of my age, but trusted her nephew's judgement. My dad thought it would be a wonderful experience to see a large section of America. This visit by cousin, Ed, put in place a whirlwind adventure for me.

I found it quite hard to concentrate on anything during the next few weeks but the forthcoming trip. I did need to spend time studying in order to successfully finish the academic year.

Logistic planning was taken on as a priority by Ed and my mother and dad. Ed estimated that the road trip to Dallas would take about five days. My folks thought I could spend up to a week there before returning home. My dad checked to find the best way for me to come home. He found that it was by train from Dallas to St. Louis, Missouri, and there, I could connect with a train to Boston's South Station. My mother said that if I was going to be in St. Louis, she would like for me to meet with her friends, Marie and Norman Teepe (these were the Army Sergeant and his wife, who spent a special Thanksgiving with us in 1943). My mother contacted her friend, Marie, who said she would be delighted to have me as house guest. This settled how I would split my trip. My dad procured my return train tickets and contacted his business associate in St. Louis, who agreed to meet me at the train station in St. Louis on my arrival there.

I told all my friends of my upcoming trip west and they all thought it sounded like an exciting adventure. One of my friends' parents thought that I was a bit too young to be coming home on my own but that was the only negative message that I heard. Ed decided to leave on Sunday, June 19, as he believed that there would be less traffic on the road through New York and New Jersey on a Sunday. Ed picked me up in his loaded down, 1941 Ford convertible around 10:30 a.m. After squeezing my suitcase into the trunk we took off on our western journey.

Ed's goal for the first day was to reach somewhere in Eastern Pennsylvania. By sunset, we were in Pennsylvania and found a motel to check into that had a

In Ed Craffey's loaded down 1941 Ford convertible, we left Brookline for a Texas adventure.

restaurant on its premises. After dinner, we both took showers and got ready for bed as Ed wanted an early start on Monday morning. We had a quick breakfast and were on the road heading west to Ohio. There were no interstates then, so travel on what today are called secondary roads took quite a bit longer. We did make it late that afternoon into Montgomery, Ohio, a small town just northeast of Cincinnati. We found a small motel and checked in. We journeyed to the downtown section and found a diner where we had supper. We then returned to the motel and again checked in early for bed. A short time after getting to sleep, I woke up sick to my stomach. I didn't improve as the night went on. Ed diagnosed my problem as being sick from the local water. He couldn't write a prescription for me as he wasn't licensed to practice in Ohio. The outcome was that he took me to the emergency room at a Cincinnati's hospital early the next morning. When I talked with an admission's person, the first question I was asked was if I would I mind being seen by a colored doctor. I was shocked by the question, as I had never had an encounter about race and only thought that this might happen in the south. I told the woman that I had no problem with the doctor. He was a young man, probably about the same age as my cousin. Ed accompanied me in for my exam and had a long talk with this doctor as to where he had gone to school, done his residency, etc., and Ed told him about his background and how we were on our way to Dallas, Texas. He gave me some medication from the hospital pharmacy and within a few hours I felt okay. After leaving the hospital, we hit the road. Due to a late start, we only reached southern Illinois by nightfall. The Midwest terrain was quite different from the New England landscape that I was familiar with.

On my Texas adventure with Ed Craffey, we drove on the legendary Route 66 in southern Illinois.

On the fourth morning of our trek west, we were on the legendary Route 66, made famous in music by the popular song "Get Your Kicks on Route 66," and in John Steinbeck's *Grapes of Wrath*, where he referred to Route 66 as the "Mother Road" that Okies used to flee the Dust Bowl for California during the Great Depression. This day we passed through St. Louis and Joplin, Missouri, as well as the Ozarks. The day provided me with an education in the differences of both the geography of America and its culture. We stopped for gas and a coke at a Mom and Pop store in the Missouri Ozarks and came in contact with folks that could have been cast as hillbillies by a Hollywood studio. We finished our travel that day at a motel close to Oklahoma.

The fifth and final day of our journey saw us pass through Oklahoma and arrive at our destination, Dallas, Texas. The road trip gave both Ed and I an opportunity to learn a great deal about each other. Although Ed was almost a decade older than me, I found out that he had been in the same high school classrooms and on the same campus that I had experienced, as he had gone to the private secondary school that was purchased by the Catholic archdiocese of Boston for the purpose of starting St. Sebastian's. I learned that when Ed was my age he didn't know whether he wanted to follow a career in medicine or music. Obviously, medicine won.

In Dallas, we checked into a motel downtown. Abutting the motel property was an International House of Pancakes (they were more formal then their present IHOP moniker), where we had dinner our first night as well as breakfast the next morning. Ed's agenda that first full day in Dallas was to check in to the Parkland Hospital and then go apartment hunting. I had the day to myself and

used it to tour around the city. I was impressed with their parks but not with the heat. I found out where the Cotton Bowl was and how to get to it, as that was on the top of the places that I wanted to see. Reconnecting with Ed, I found that he had been fortunate in finding an apartment. Ed showed me the Parkland Hospital where he would be working, and gave me a car tour of Dallas. Little did I know that in November of 1963, I would again see the Parkland Hospital on TV when JFK was shot and brought there; he was pronounced dead, and two days later, when Jack Ruby shot Oswald, he also ended up at the Parkland Hospital. I helped Ed unpack the car and bring all of the items into the newly rented apartment. Most of the things were baby items for little Ann. On the weekend, Marion and Ann arrived tired, but happy to start a new life in Dallas.

On Tuesday, June 28, I started the first leg of my journey home and boarded the train for St. Louis. I settled into the coach and spend the first few hours looking out the window at the changing countryside. We reached Texarkana about 5:30 p.m., and that's when a railroad employee came through our coach with food and drinks for sale. I purchased a sandwich, chips and a milk. Daylight soon faded but the light in the coach remained on as I dozed off from time to time during the night. We eventually arrived in St. Louis, where I was met by my father's associate. He took me to lunch and then brought me to see the St. Louis Zoo, which was wonderful, as the animals had lots of room to roam around and were not confined to just cages. We left the zoo in the late afternoon and he then took me to Marie and Norman Teepe's home. We had a very nice evening with a

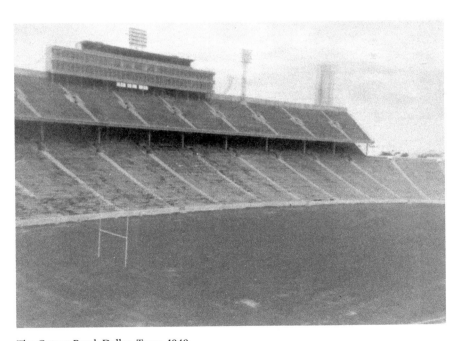

The Cotton Bowl, Dallas, Texas, 1949.

lot of discussion abound our Thanksgiving together back in 1943, and how Marie and my mother had kept up their friendship over the years. Marie and Norman both worked for Anheuser-Busch. Marie was a secretary and Norman worked in Budweiser production. Marie took Wednesday off so she could show me around the city. We had a great day touring and I learned a great deal about St. Louis.

On Thursday morning, June 30, I said my goodbyes and thanks to Marie and Norman, and took a cab to the railroad station. After finding the track my train was leaving from, I was set to start the final trek of my journey. The coach trip to Boston's South Station was quite long but not too eventful. My dining was essentially a repeat performance of my Dallas–St. Louis trip: a sandwich, snack and milk. The following morning, I bought a donut and milk for breakfast. I was tired when we finally pulled into the South Station. After disembarking and entering the station, I went to the ticket counter and found out when the next Highland Branch train was leaving for Brookline and purchased my ticket. Thankfully, I didn't have to wait long for my final ride home. I was glad to be home when I got off the train to Brookline Hills.

I made it home in time to celebrate my mother's birthday, July 4, and start my summer job on Tuesday, July 5. I was certainly glad that I had the opportunity to see a major part of the country and was excited at what lay just ahead, as over the next year I would be graduating from St. Sebastian's and hopefully going off to college. It seemed then that lifetime passages were coming at me at an extremely fast pace; while they were desirable and challenging, they were also quite scary for one moving toward manhood.

Transition

For the third year, I was fortunate in receiving an appointment for a summer job with the Metropolitan District Commission (MDC). My 1949 summer job assignment was helping to sweep roads and pick up trash that had been tossed. The crew that I was assigned to was made up of college students and fellows who had been recently released from prison. Like in past summers, the appointment was to run until mid-August.

My Texas adventure proved to be a fantastic educational experience that I would not have found in school. The long road trip introduced me to the natural diversity of our country's geography as well as the cultural differences that exist.

On one of mid-August's dog days, Randy Filmore, Herb Meehan and I hung out at the Cypress Street Playground after a swim at the Tank. We were joined by Mike Dukakis and Bob Palmer. We five teens, on the edge of adulthood, discussed our upcoming fall plans as well as some of our hopes for the future. Herb was the oldest of our group. He had graduated from Brookline High in June and was going to be starting his freshman year at Boston College in a few weeks. I was looking forward to heading back to St .Sebastian's in a couple of days for the start of football practice. Bob, Mike and Randy were getting set for their Junior year at Brookline High. Mike was the most vocal about his plans for the future. He told us, that he wanted to enter the local political world and represent Brookline in the Massachusetts legislature as a Democratic State Representative. That seemed to me to be a very big dream, as Brookline had always been a Republican stronghold and had never, in my sixteen years, elected a Democrat to the state house of representatives. The rest of us had not formulated such long range plans.

Little did any of us know what the future held. In a few short years, my best friend, Randy, would be a U.S. Navy pilot. As a young lieutenant serving in the Mediterranean, he was tragically killed in a plane crash. Herb earned his degree in mathematics at Boston College, and after a stint in the Army, went on to a high school Math teaching career. The future had even bigger plans than serving in the state legislature for Mike. He became governor of the Commonwealth of

Left: Lt. Leroy Randall Filmore Jr., U.S. Navy, 1933-1958.
Randy was killed in a plane crash during a naval exercise in the Mediterranean.

Below: The St. Sebastian's JV football squad, fall 1947.

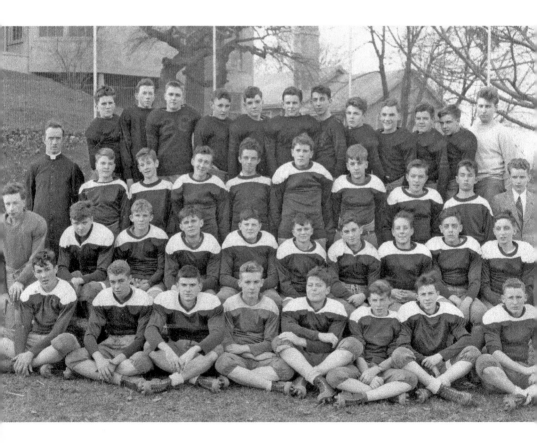

Massachusetts for three terms, the longest of any governor, and then became the Democratic nominee for president in 1988 but lost to Vice President George W. H. Bush in a hard-fought campaign. After college, Bob went on to pursue a career as a public relations executive with a major corporation.

I returned to Nonantum Hill for football practice. We opened our season with a loss to Cambridge Latin. Our season had us traveling to two overnight away games. The first was with Hopkins Country Day in New Haven, which was a loss, and the second was with Cranwell Prep in Lenox, Massachusetts. For a second year, I was awarded a school jacket. That hockey season, I served as the team's manager and played again on the water polo team, which gained me a total of three varsity letters. Other extra-curricular activities that I enjoyed included the choir and the annual Minstrel Show. In that year's performance, I did a comedy solo, singing "I'm A Lonely Little Petunia in an Onion Patch," dressed as a petunia

On the academic scene, my studies included: English with Father Sylvester, American History with Father Keating, Physics with Father Harrington, Trigonometry with Father Gilmartin and Religion with Father Shea. I wanted to do well academically, since I would be applying to colleges and taking College Board Exams during my senior year.

I was undecided where I'd like to go to college as I didn't really know what I wanted for a career. My career thoughts included communications, law and teaching. Earlier, I had thought about dentistry, but in my senior year I had ruled it out. My college choices were Brown University, Boston College, Harvard University and St. Francis University in Loretto, Pennsylvania. All offered liberal arts programs, which would provide maximum flexibility until I figured out what I wanted for a career.

On a Saturday morning in early December, my dad and I went over to the bookstores in Harvard Square to check out books that would help me prepare for my upcoming College Board Exams. We found several that seemed appropriate. I planned to use some time during the holidays to bone up for the tests. I also wanted to have some fun time with friends.

With the holidays over, it was time to resume classes. On most weekends, I'd go out with my friends to either the RKO in Boston, where we could see a movie and a live show by major performers, or go to a hockey game. We also found a bar on South Huntington Avenue in Roxbury where we could get beers without being carded. A draft beer cost ten cents and were called "dimies." We thought we were real big shots having a beer in a pub.

In March it was time for College Board Exams. They were held at Boston Latin School on a Saturday and were a whole day event. The exams were not a multiple choice style and machine scored. These tests involved a lot of essay-style answers. In addition to the College Board Exams, Boston College required applicants to take their exam, which was similar in style and was held

at the college in early April. After taking the exams and sending in all of the required paperwork, it was just a wait to receive a response from the admission's department.

On a Friday night in late April, Gerry Powers suggested that he and I go and see a burlesque show in Scully Square with Gerry McCourt. In those days, Scully Square was famous and/or infamous for its sleaze bars and burlesque theatres including both The Old Howard Theatre and The Casino. We chose for this rite of passage The Old Howard, where we saw several slapstick vaudeville acts and a couple of strip tease numbers. During the 60s, Scully Square was completely demolished and rebuilt, and renamed Government Center.

Late April saw the start of letters coming from college admission offices. Some of my classmates had received notification on their acceptance to different schools. My first letter came from Brown; I opened it and found that I had not made the cut. Naturally, I was disappointed. Two of my friends, Joe Shea and Ernie Woelfel, heard that they had been accepted. A week later, a letter came to me from Boston College, stating that I had been accepted into the Arts & Science School Class of 1954. I was very excited, knowing that my next four years would be on the Heights. I found out that classmates, Danny Burns, Bill Carey and Gerry McCourt, would also be joining me at BC. That same week, Jimmy Delay, Gerry Powers and Bob Zock received the news that they had been accepted into the Harvard Class of 1954. By the end of May, all of my St. Sebastian's classmates had been accepted to major colleges.

During our four years on the Hill, we gained an appreciation of the special place that St. Sebastian's was, with its rigorous academic standards, Christian teachings, great teachers and a very special headmaster who had implemented the perfect rituals for a first-class prep school. When St. Sebastian's was established in 1941, a class system still existed in the Boston area. The Brahmins with their old money still held power, and Catholics, Jews and other minorities were still considered second-class citizens. Intuitively we knew that we were on a par with the other fine old Yankee prep schools, but we still were not accepted as equals. The election of JFK as president ended the Brahmin hold on Boston power and changed forever the access to more opportunities for all people.

In September 1950, I started my college career at Boston College as a history major, and that fall was a member of the BC Freshman undefeated football team.

The fall of 2016 saw St. Sebastian's mark its 75th Anniversary. The school no longer resides on Nonantum Hill in Newton, as it moved in 1983 to a large 26-acre campus in Needham. In addition to serving as a high school, it has added grades seven and eight. The faculty is now made up of men and women. There are no longer any priests on the faculty. The school continues to maintain its rigorous academic program and excellent sports teams. In 1973, St. Sebastian's became a member of the elite Independent School League, often called the Ivy

Going to my freshman class at Boston College in the fall of 1950.

League of Prep Schools. Many of its members have a storied history including Roxbury Latin, founded in 1645; The Governor's Academy, founded in 1763; Lawrence Academy founded in 1793; Milton Academy, founded in 1798; and Groton, St. Mark's and St. George, which are among its sixteen members. I am pleased to be an Arrow alumnus. Much of my worldview was shaped during my four years on the Hill.

About the Author

Jim Harnedy is an octogenarian and a native of Brookline, Massachusetts. He has resided in his adopted state of Maine for nearly four decades with his artist wife, Jane Diggins Harnedy. He is a retired computer executive and in his second career, has authored nine books as well as a number of articles for both local and national publications. He did his college preparatory work at St. Sebastian's School and received his Bachelor's Degree in History from Boston College. He did post graduate work at Georgetown University and at Framingham State College.

His many interests have included organic gardening, raising and showing Kerry Blue Terriers, camping, reading and enjoying the changing seasons that New England provides.

Jim has been active in both his community and church. Since a health issue required him to downsize his medium-sized canine companions, he has acquired a wonderful little Scot, named Duncan, a West Highland White Terrier.

Jim and Jane are the parents of two daughters and have four grandchildren, and nine great-grandchildren.

Jim, Jane, and Duncan live way down east in Bucks Harbor, Machiasport, Maine.

Author Jim Harnedy with his West Highland White Terrier, Duncan.

Other Books by the Author

Images of America: The Boothbay Harbor Region (1995)
Images of America: Around Wiscasset (1996)
Maine: The Best Images of America, Selections (2000)
Images of America: The Machias Bay Region (2001) with Jane Diggins Harnedy
Scenes of America: The Boothbay Harbor Region (2006)
Scenes of America: The Machias Bay Region (2006) with Jane Diggins Harnedy
The above books published by Arcadia Publishing

Images of Canada: Campobello Island (2003) with Jane Diggins Harnedy
Jointly released by Arcadia Publishing and Vanwell Publishing Limited

A Handy Guide for Eucharistic Ministers (2001) – Jane Diggins Harnedy with Jim
 Harnedy
ALBA HOUSE Publishers

Historic Churches, Synagogues and Spiritual Places in Eastern Maine (2011) with
 Jane Diggins Harnedy
The History Press